Winter 2015 Art

Art Auction

By
SHAN PECK

Copyright © 2015 Shan Peck

All rights reserved.

Printed in the U.S.A.

ISBN-13: 978-1522930129

Dedication

For all people that love art.

FEATURED ARTISTS

JUKKA NOPSANEN - FINLAND

RERA KRYZHNAYA - RUSSIA

JANET LAVIDA - U.S.A.

JILIAN CRAMB - U.S.A.

PAMELA MEREDITH - AUSTRALIA

MICK WILIAMS - U.S.A.

DENISE FULMER - U.S.A.

PAMELA CLEMENTS - U.S.A.

LIDIA ESSEN - RUSSIA

GARY SLUZEWSKI - U.S.A.

TIMOTHY HACKER - U.S.A.

MARGARET BROOKS - ST. MAARTEN

PAT GEHR - U.S.A.

DONNA COOK - U.S.A.

ROBERT YAEGER - U.S.A.

LOIS VIGUIER - FRANCE

JAYNE SOMOGY - U.S.A.

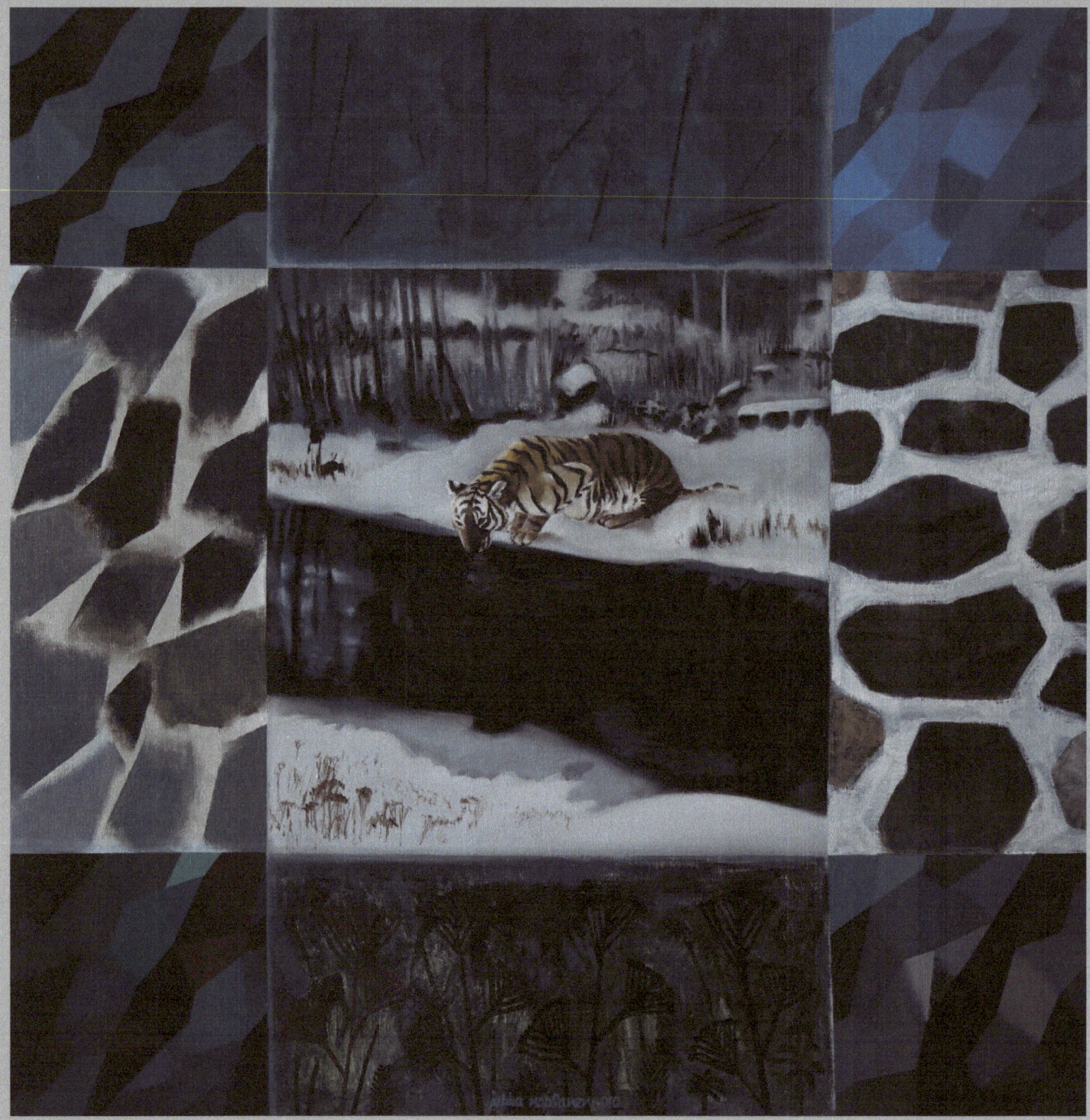

FAR FROM HOME - ART BY JUKKA NOPSANEN
110 X 110 CENTIMETERS
MEDIA - OIL ON CANVAS
$6,000.00

jukka.nopsanen@kolumbus.fi

Author

In the seventies, during the decade of political participation, I painted the 'fables'. In these metaphorical paintings, the figures with heads of animals, depicted different features of the human nature.

In the eighties the shades became darker and the figures were transformed into abstractions. I called them discoveries from a destroyed ancient culture. That's how the 'archaeological diggins' were initiated. It was a reaction against the instant culture.

In the 90's my broken view of the world was 'crystallized' in mosaic patterns desrcibing the relationship between man and nature and the problems of the human spirit.

From the beginning of this millennium I have started to combine the figurative and abstract elements into a sort of a synthesis of the past. I combine new and old ideas trying to paint an image of the human spirit.

As a portrait painter

Concurrently with my development as an artist I have studied portrait painting from its traditional point of view approaching a portrait which combines classical figures and my personal expression.

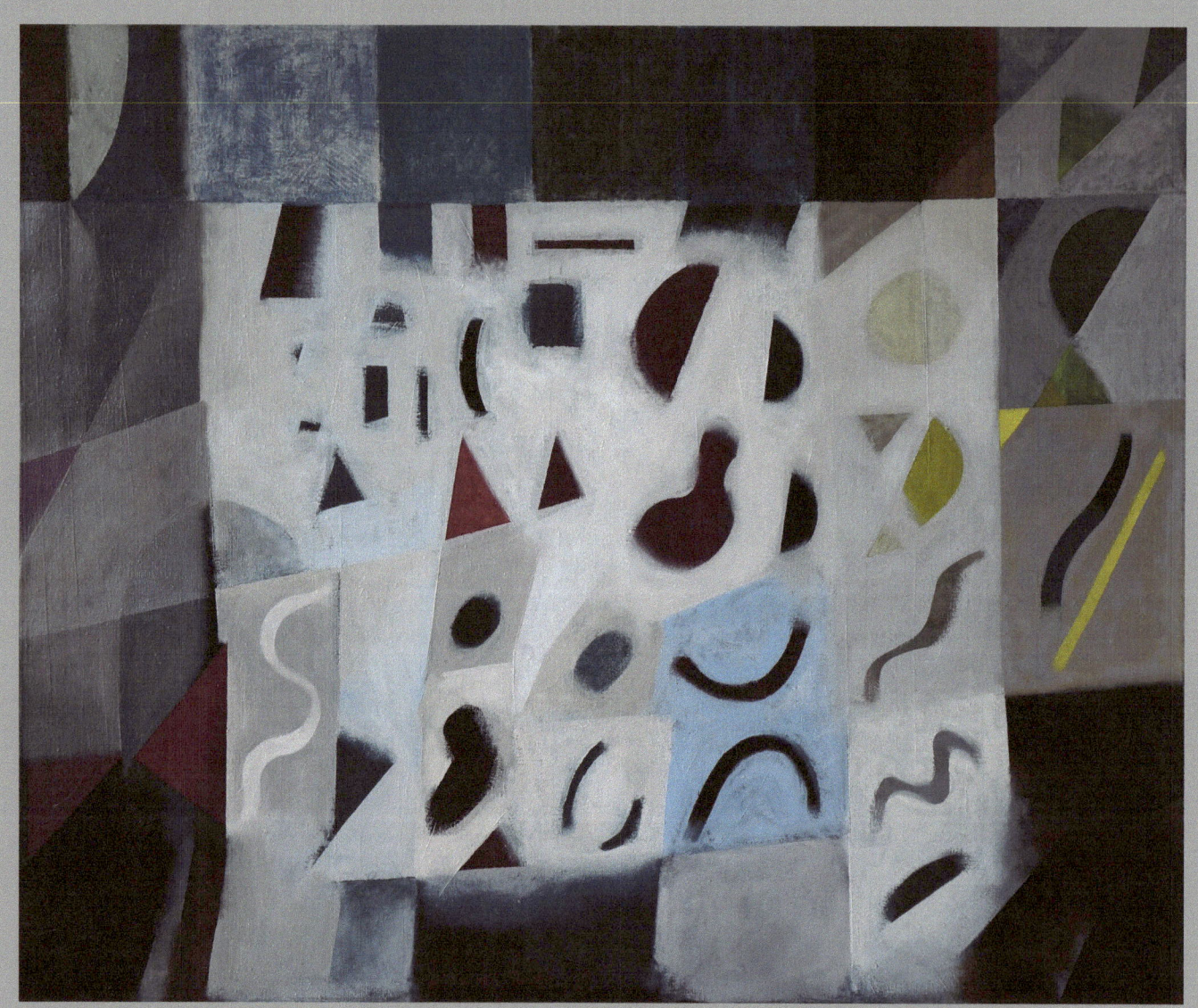

ENIGMA - ART BY JUKKA NOPSANEN
81 X 100 CENTIMETERS
MEDIA - OIL ON CANVAS
$6,000.00
jukka.nopsanen@kolumbus.fi

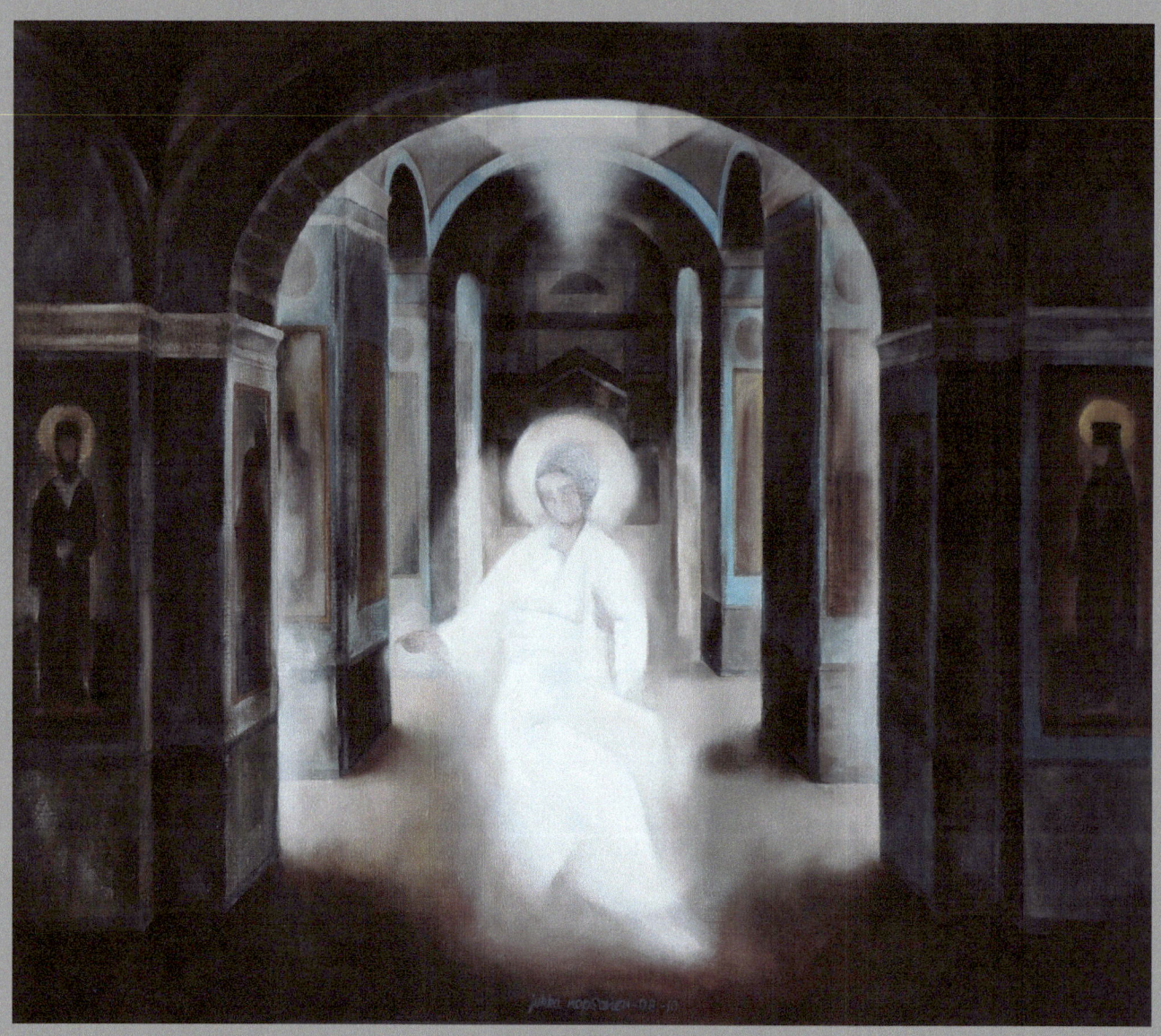

RELEVATION - ART BY JUKKA NOPSANEN
100 X 120 CENTIMETERS
MEDIA - OIL ON CANVAS
$7,000.00
jukka.nopsanen@kolumbus.fi

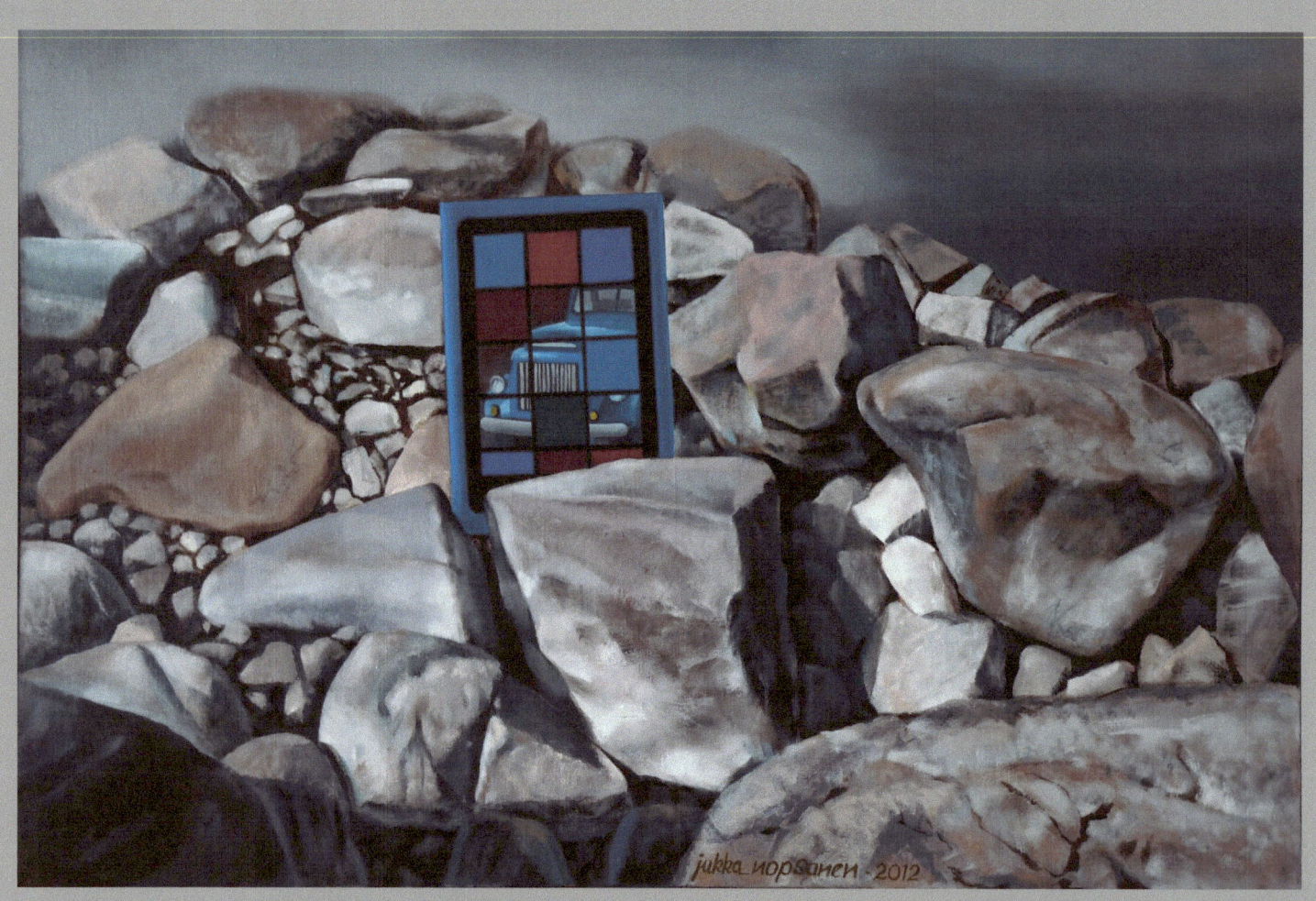

THE ICON OF TODAY - ART
BY JUKKA NOPSANEN
65 X 100 CENTIMETERS
MEDIA - OIL ON CANVAS
$5,000.00
jukka.nopsanen@kolumbus.fi

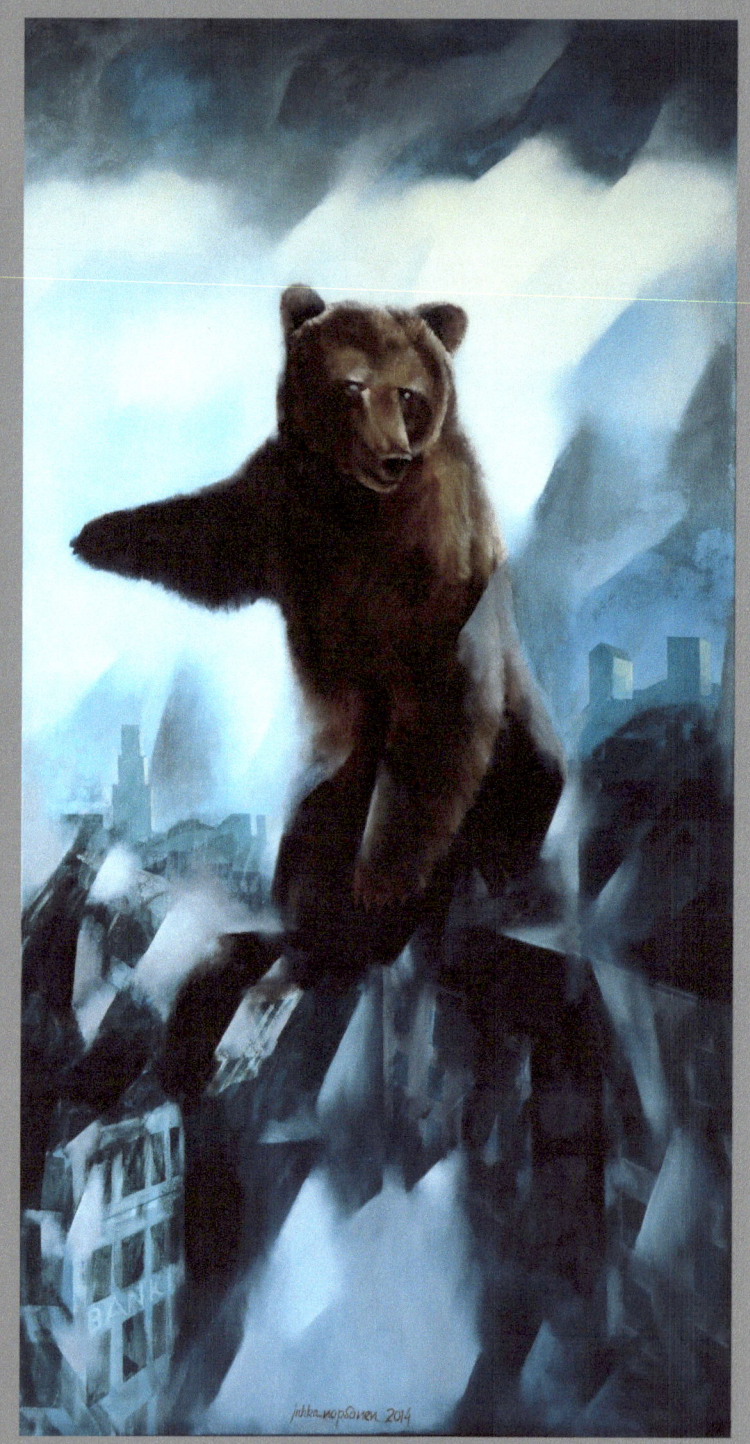

DEVASTATION - ART BY JUKKA NOPSANEN
150 X 80 CENTIMETERS
MEDIA - OIL ON CANVAS
$7,000.00
jukka.nopsanen@kolumbus.fi

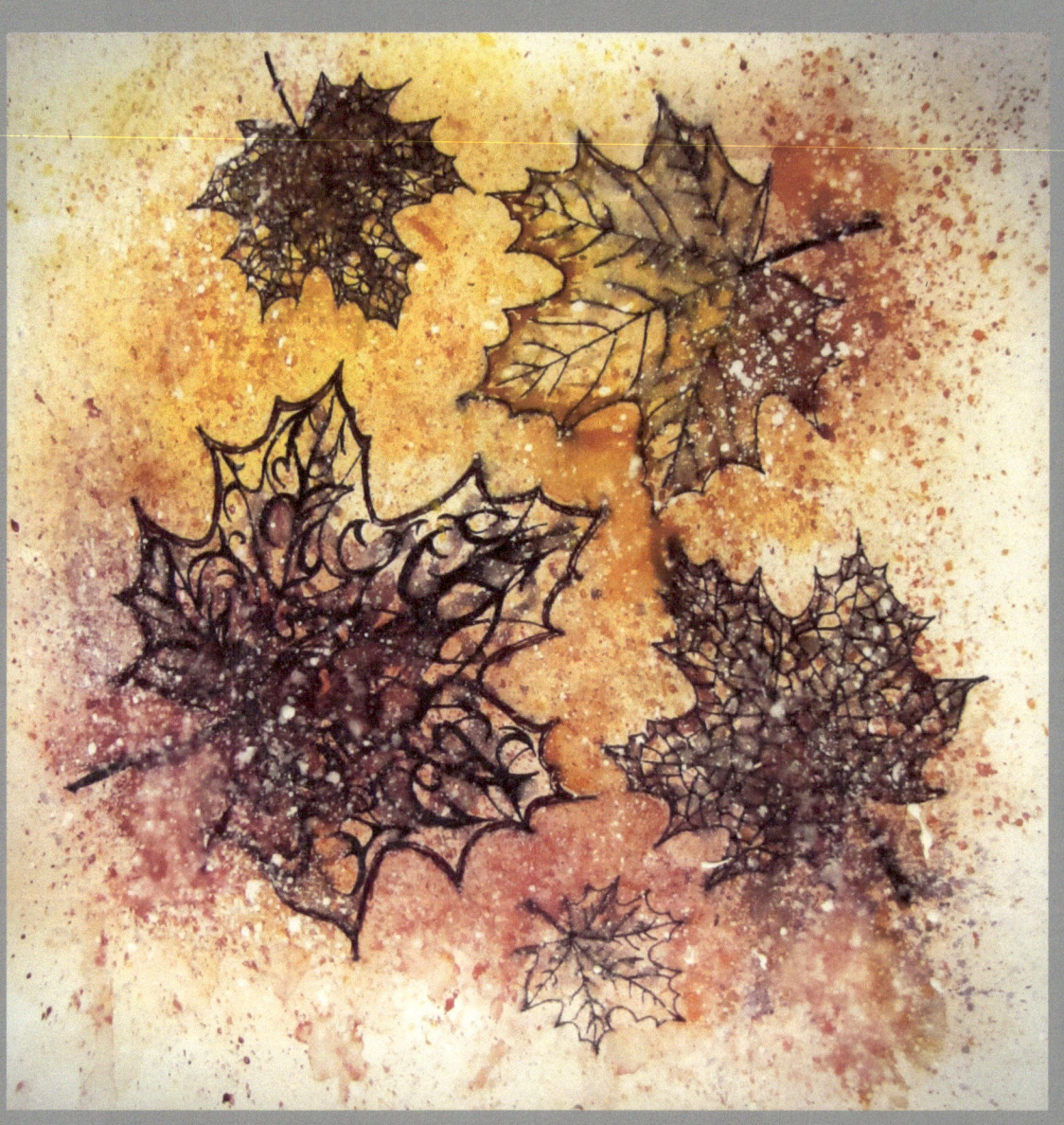

AUTUMN LEAVES / BRIGHTNESS OF FALL – ART BY RERA KRYZHNAYA
11.7 X 11.7 INCHES
MEDIA - WATERCOLOR AND INK ON PAPER
$ 50.00

kryzhnaya@gmail.com

Author

I'm an inspired artist, working in watercolor, ink, acrylic and sometimes oil. Art is my life, work and passion. I have drawn pictures, since I was 5 years old. I have participated in many art contests and festivals and won near 15 awards. I graduated in an art school and entered a university, majoring in Environmental Design and Art.

In many cases, a theme of my artworks is deeply related to oriental values. This is because the Asian art is very close to my heart and soul. I lived in Asia including Japan and South Korea for learning their art and understanding their artistic perception.

I sincerely hope my artworks bring you harmony, peace and love.

Contact:
My websites:
http://vk.com/artbyrera
FB:
http://www.facebook.com/airu27
INSTAGRAM:
https://instagram.com/rera_artist/

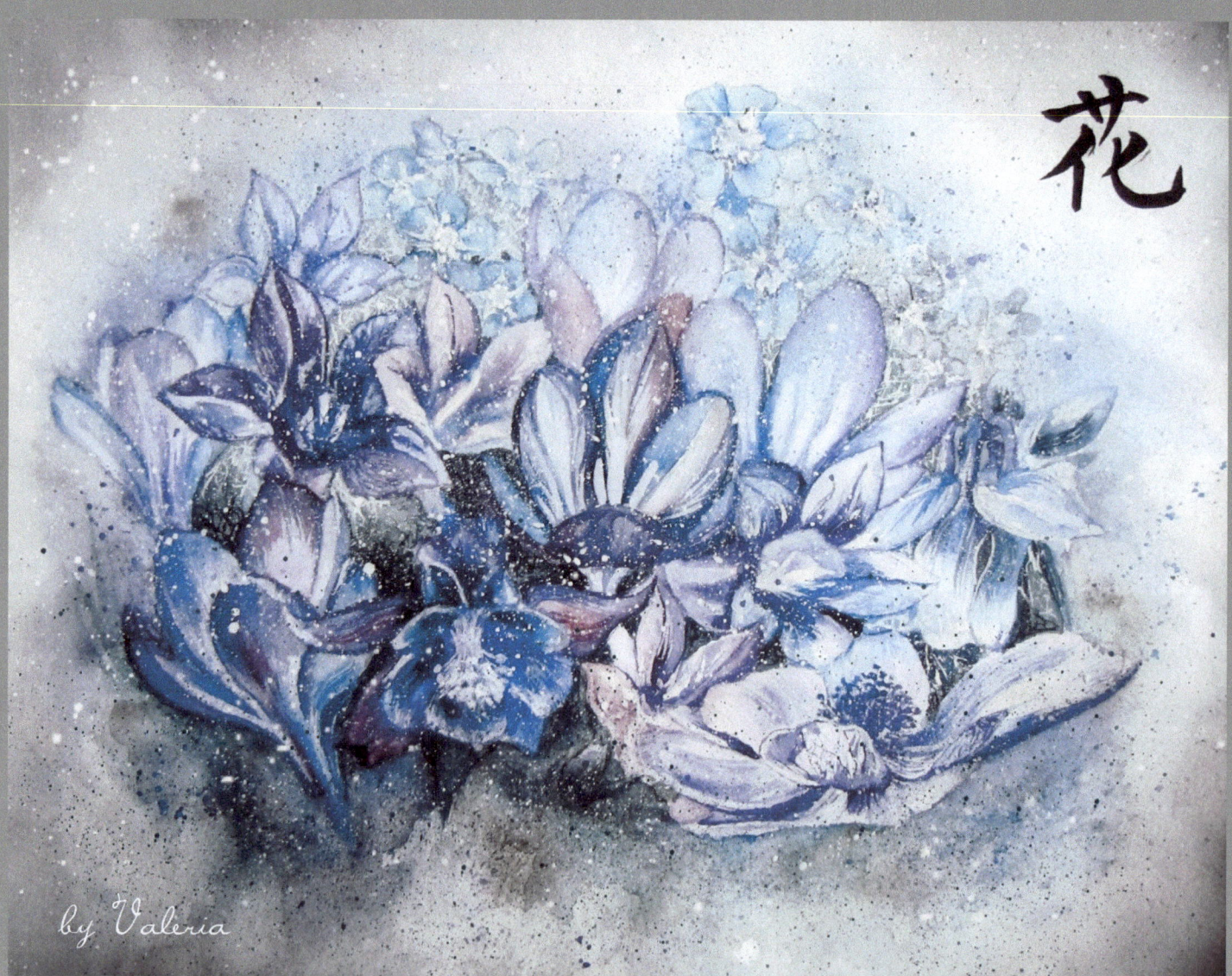

HANA / FLOWERS – ART BY
RERA KRYZHNAYA
16.5 X 11.7 INCHES
MEDIA - WATERCOLOR AND INK ON PAPER
$300.00
kryzhnaya@gmail.com

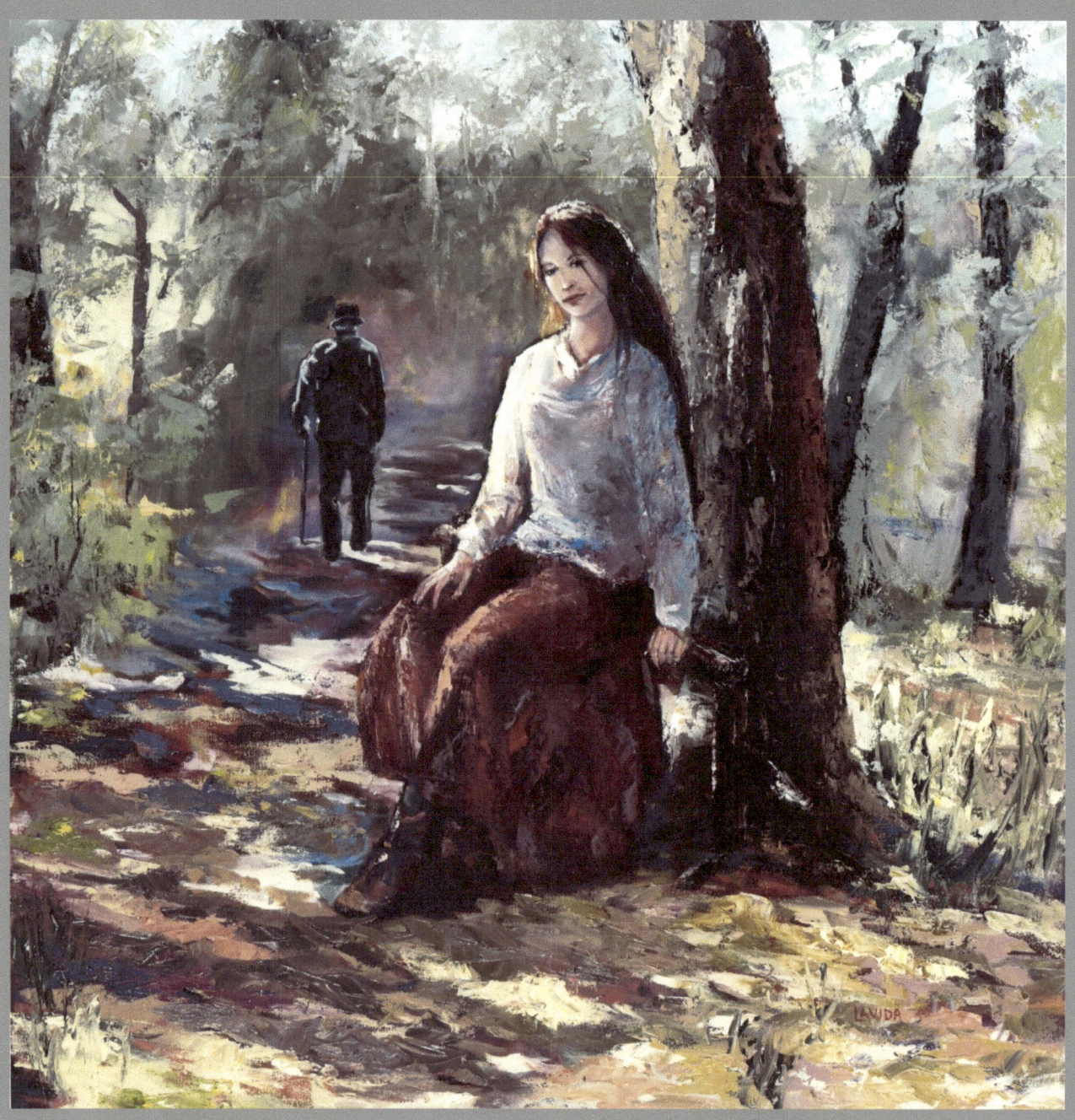

A QUIET SEASON – ART BY JANET LAVIDA
30.0 X 30.0 INCHES
MEDIA - OIL ON CANVAS
$7000.00

jlavida@aol.com

<u>Author</u>

 I was born in the Chicago suburbs and lived there for the better part of my life. My love for art began in those formative years. No doubt the influence of my mother, having been an artist herself, was the stepping stone that enhanced my love to become a giver.

'GIVERS'

A painters brush, a composer's notes, a poet's pen, all share in the opening up and the leading through countless corridors of a universe within a universe. For each grasps beyond the limitations of mere sight, sound, and understanding. The artistic reach extends between the real and the imagined. They have earned the art of constancy, by way of continually being. Their expression, be it either masqueraded before your face, echoed through your mind, or simply pressed across your heart, are the gifts from these givers. With clarity, they are but one language holding powers to cross all barriers. The artist is ageless and shows no favoritism to the young nor the old. The givers are timeless, for they are before, they are after, they are now, and thus, forever be they the always. A 'Giver' among 'Givers'

In school my talents were first recognized. However, it was approximately at the age of twenty-five that I realized a fuller potential. It was then that I began to take my art to a more professional level. My enriched desire to paint began to intensify, and as I developed physically, mentally, and emotionally, I broadened my artistry to encompass the passionate world around me.

I am a self-taught artist, using my own technique, which is my signature. Although, I have painted with water color, and acrylic, it has been my preference to use the oil medium. Yet, people most interest me. I try my best to capture the essence of the individual and place it upon my canvas. I am not subject to doing only portraits, for I do have eyes for all things, the animate and inanimate. Having placed my signature upon murals, canvas, book covers, and the like. I would like to broaden my field, to include you.

COTTON SPICE – ART BY JILIAN CRAMB
16.0 X 20.0 INCHES
ACRYLIC ON CANVAS
$142.00

asherjacobsmommy@gmail.com

Author

I am a single mother of a happy, energetic 2 year-old boy, Asher. My background is in Interior Design; I am formally trained in computer-aided design, but also hand-rendering and sketching techniques.

A little about my work: I used to think I was 'all over the place' but there are just SO many styles and subjects - why not do as many as I can!? Realism is about the only thing you won't find here, a fluke here and there! Why paint things as they are, when, with a paint brush and canvas, anything in any color is possible!? Never stop dreaming or creating!

**CAMDEN FAR – ART BY
PAMELA MEREDITH
35.5 X 46 CENTIMETERS
MEDIA - OIL ON WOODEN BOARD
$360.00**
pmeredith6@bigpond.com

Author

I live on the east coast of Australia at Bulli right near the beach. I paint mostly in oils but I am painting in other mediums too. I learnt to paint in oils from a local teaching artists Peter Bates from the year 2000. I have done many workshops and have learnt a great deal about art from these workshops. I am the president of the Illawarra Arts Society inc and have sold many painting with their exhibitions. I really enjoy painting and loose myself in my work. My way of relaxation is to go to my studio put on a CD and paint.

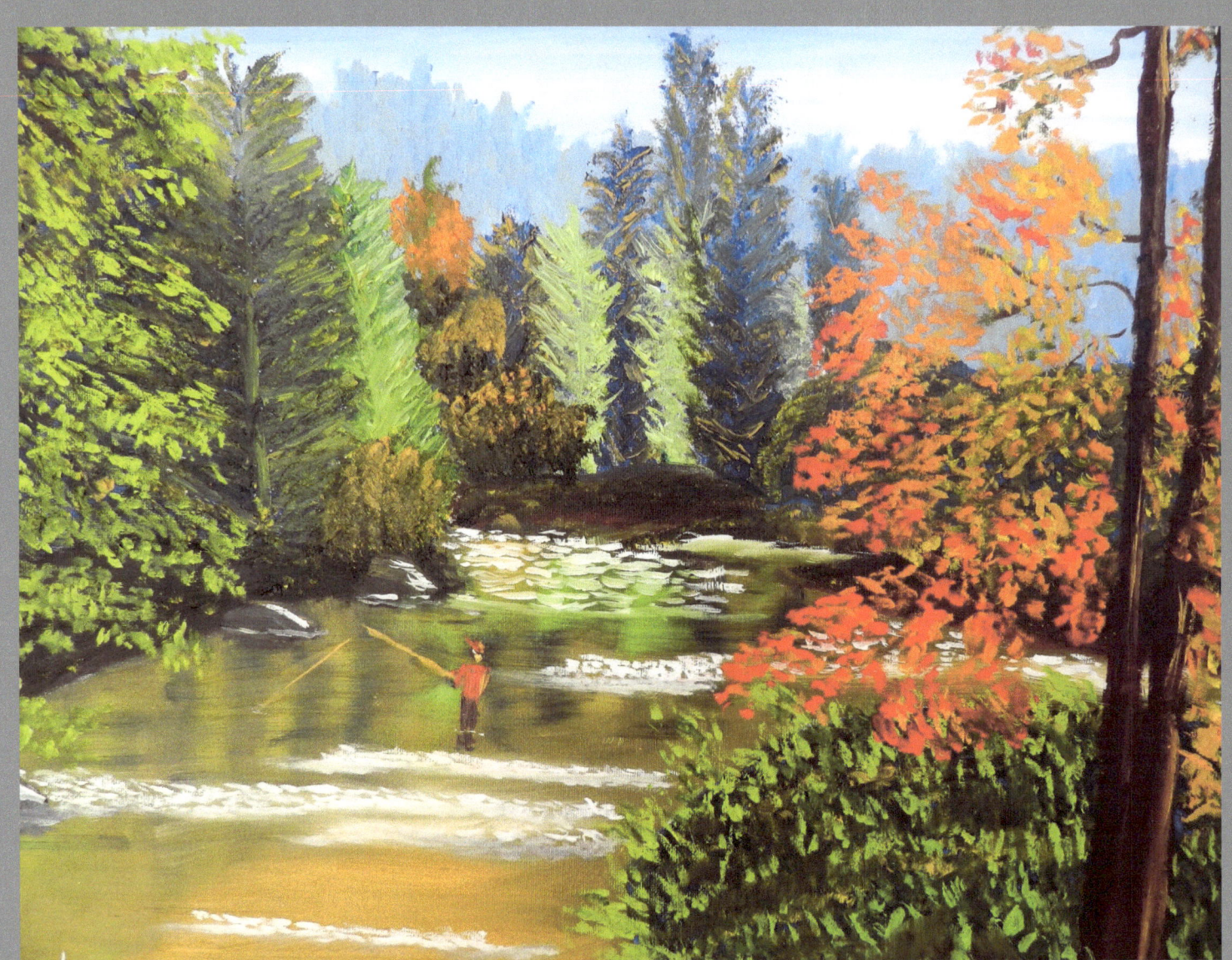

MOUNTAIN STREAM – ART BY
PAMELA MEREDITH
40 X 50 CENTIMETERS
MEDIA - OIL ON CANVAS
$360.00
pmeredith6@bigpond.com

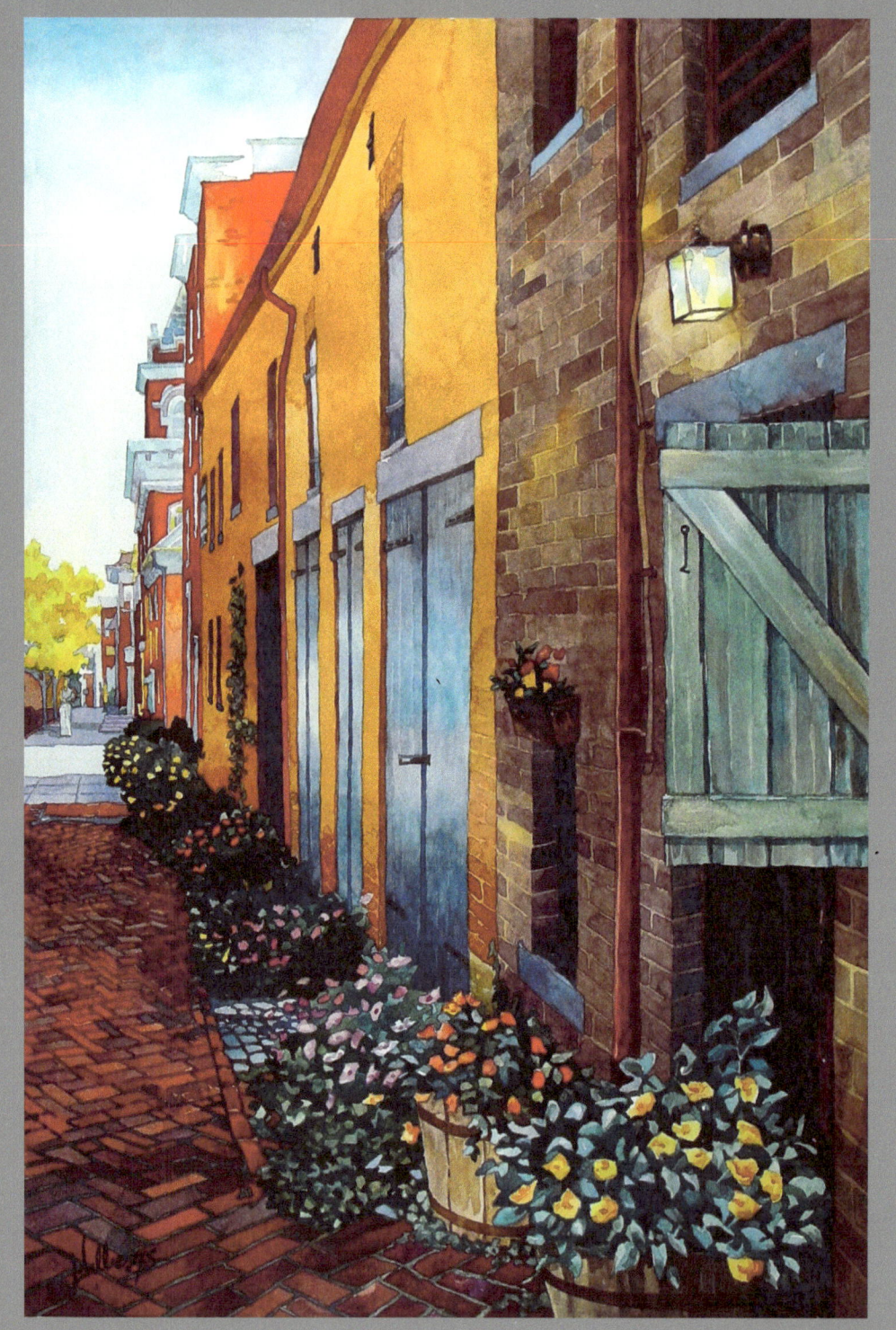

WEATHERED DOOR RUSTIC PATH – ART BY MICK WILLIAMS
14.5 X 21.5 INCHES
MEDIA - WATERCOLOR
$ 850.00

fineartbymick@gmail.com

Author

Mick Williams is a Maryland artist specializing in vibrant realist watercolor landscapes, jazz and blues imagery, portraits and still life paintings. He is a graduate of the Art Institute of Pittsburgh with a degree in Visual Communications.
Williams is a signature member of the Baltimore Watercolor Society, as well as the Delaplaine Arts Organization, Mid-Atlantic Plein Aire Painters, and the Frederick County Arts Association.

Mick has enjoyed a long career in visual arts, with an extensive background as graphic artist, art director and syndicated cartoonist. In 2002, Williams was honored to create a series of paintings to represent the goals of Champions of Hope, an international youth service organization with roots in more than 200 countries. He presented these works to the charity's founders during a global ceremony at the Israeli Embassy in Washington, D.C. Other charitable groups have sought his talents to create exclusive paintings, including the Murphy-Harbst House for Fragile Children and Habitat for Humanity, who commissioned a painting for a fundraiser. He has received many awards and honors, including having his work selected to represent the 2006 Western Maryland Blues Festival and the 2007 City of Frederick Holiday Poster. Mick created the February 2012 cover of Frederick Gorilla magazine, a charcoal portrait.

Mick has competed in many plein aire painting events in the Mid-Atlantic area including 3 times participating in the Easels in Frederick National competition.

The artists that most inspire Mick are Camille Pissarro, Cezanne, Van Gogh, Winslow Homer, and more recently Frank Webb, and C. W. Mundy. Henry Koerner and Flavia Zortia from the Art Institute of Pittsburgh, and post graduate, Watercolor painting the Edgar Whitney way formed Mick's fine art education.

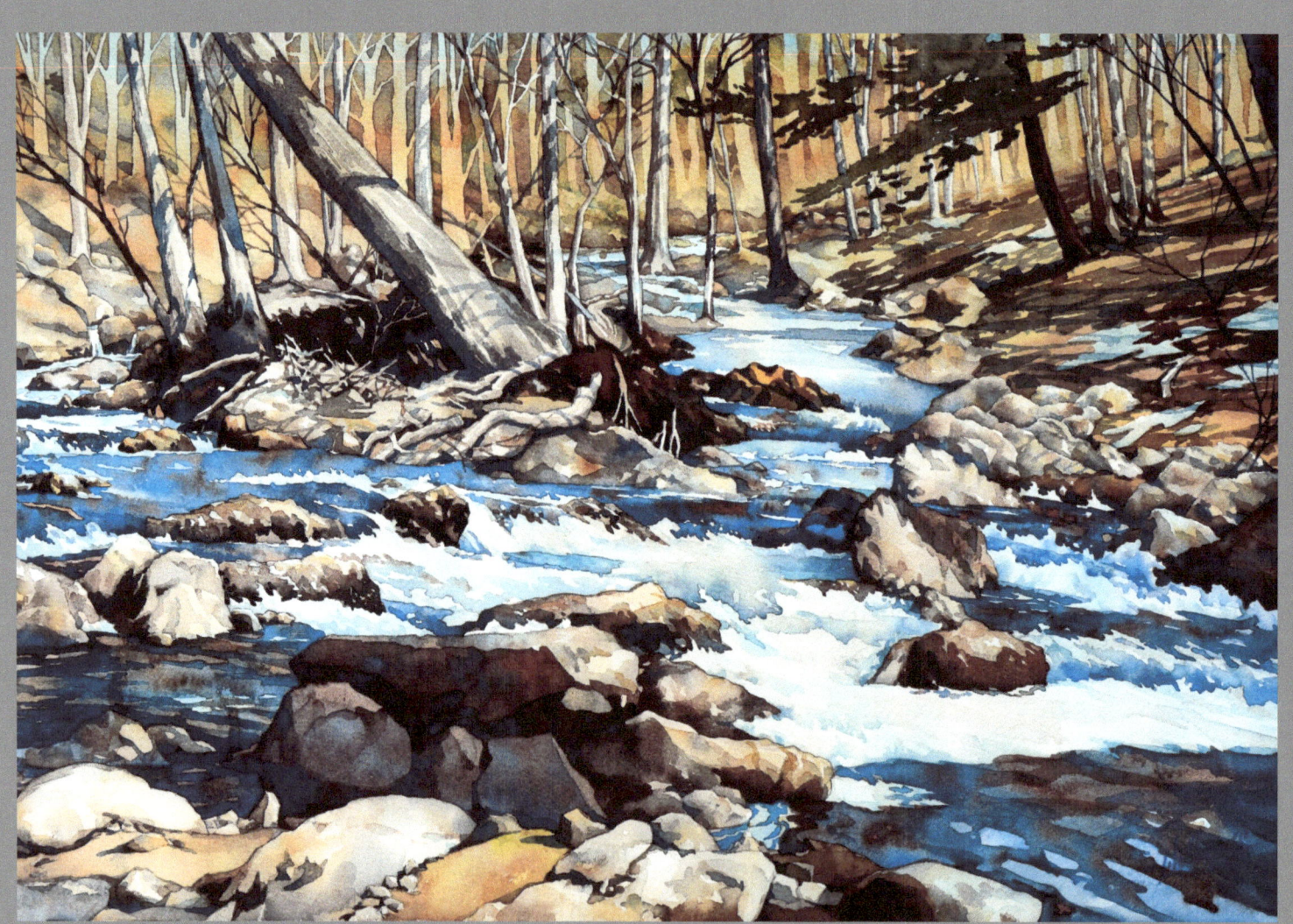

SPRING THAW – ART BY MICK WILLIAMS
22 X 15 INCHES
MEDIA - WATERCOLOR
$ 850.00
fineartbymick@gmail.com

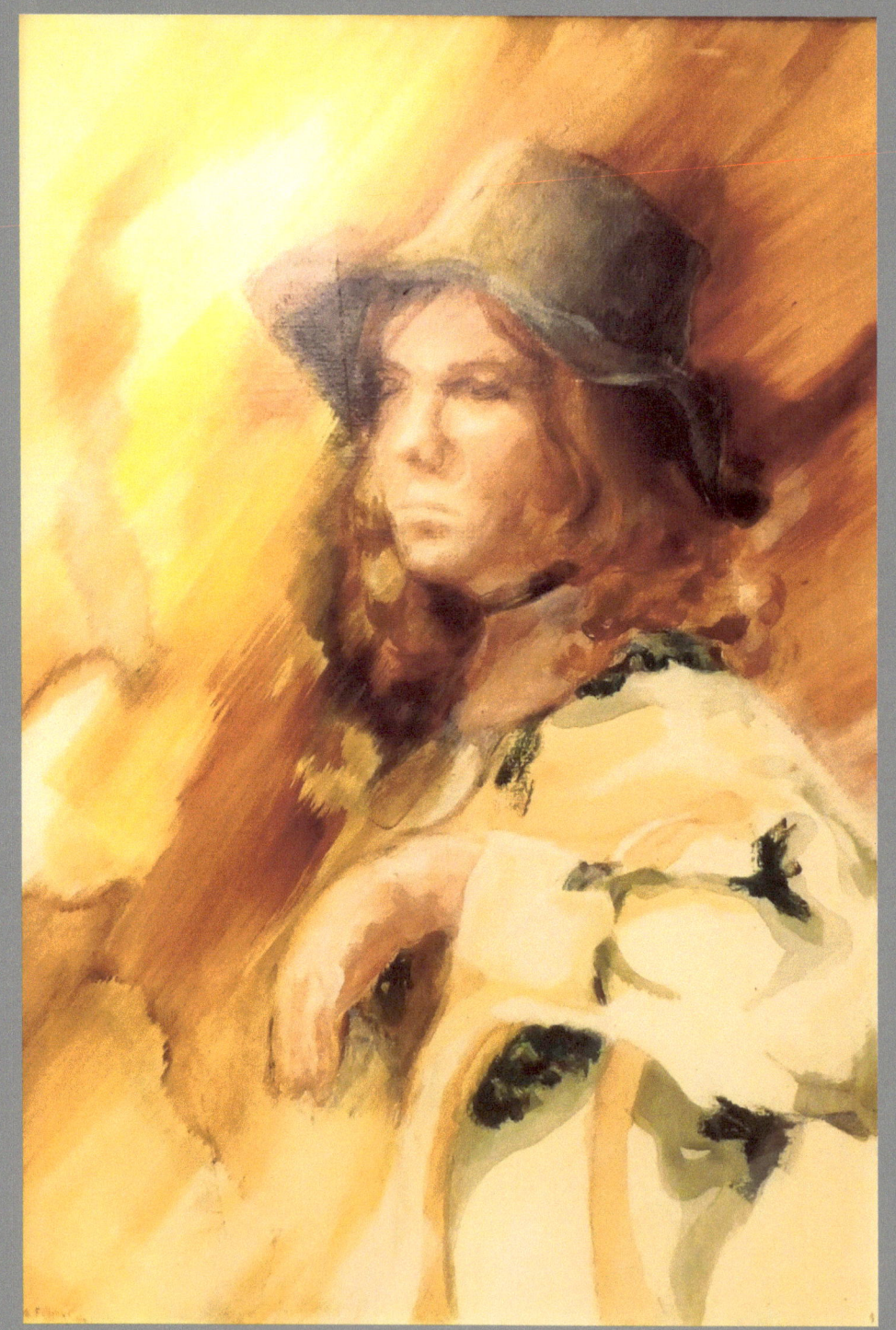

TANGY – ART BY DENISE FULMER
22 X 30 INCHES
MEDIA - ACRYLIC ON CANVAS
$ 150.00

dffladybug@gmail.com

Author

I knew I wanted to be an artist of some kind since age 3. I majored in art at Furman University, class of 1973. I received the Mattie Hipp Cunningham scholarship for excellence in creativity in the visual arts my junior year 1972. I have worked professionally as a technical illustrator and freelanced doing paintings and drawings. I have created hand-woven items and sold them at craft fairs. I have created cloth dolls and stuffed animals and donated them to children at Christmas through toy drives locally. I have created 10 self-published books through Blurb.com. Five are on Amazon.com and eight are in the Apple iBookstore in eBook format. In 2008, I was diagnosed with Parkinson's disease. I still do drawings currently to sell through FineArtAmerica.com and my own website: http://2-denise-fulmer.artistwebsites.com I am still an artist no matter what condition my body is in. Being an artist is a condition of the soul.

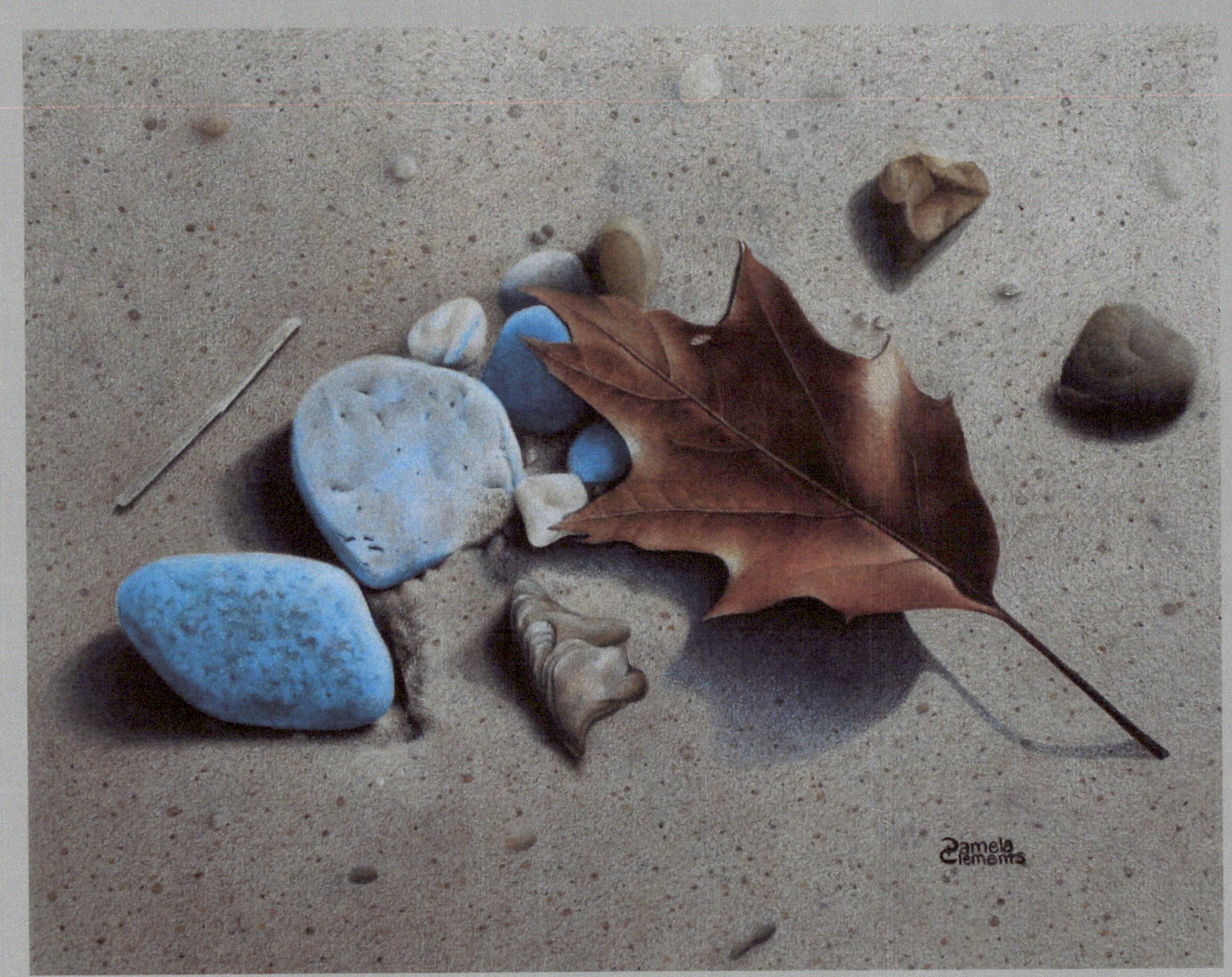

BEACH STILL LIFE II – ART BY PAMELA CLEMENTS
11.75 X 8.75 INCHES
MEDIA - COLORED PENCIL
$ 500.00

pamela.clements@sbcglobal.net

Author

I am and have always been an artist. I officially became known as an artist in elementary school when I was selected, by default, to draw our class' open house project. At the time it was a large and a very important appointment for a third grader but it was that feeling of pride, accomplishment, and satisfaction which accompanied that first public art assignment that stayed with me. Of course this allowed other artistic opportunities to come my way throughout all of my school years affirming the decision to make my growing passion a career.

That career has varied over the years starting with my BA from Indiana University Bloomington in both drawing and graphic design. I worked in the graphic design field as an artist for a printer, a publisher and an advertising agency before having a family. I learned deadlines, how to get the job done and to communicate visually to satisfy the client. After a few years off with two young boys, I returned to the art field as an educator teaching art for grades K-8 plus after school specialty art classes. Without deadlines and client specifications, the fun and joy of creating artworks with kids revived my own childhood memories. As my boys have grown and left for college, I have redefined my art career again. I have always created art and I'm still teaching it but now I felt the desire to define and discover my own art.

A few years ago, I started back at the beginning, creating artwork by refocusing on the drawing media and skills which I have continued to study, practice, and strive to perfect. From color pencil to graphite, my tools of choice, I remain an artist discovering new subjects from evolving personal artistic perceptions. A graphic design education teaches how to grab a viewer in just a few seconds. A drawing education teaches how to hold the viewer with amazing artistic skill. An arts education teaches how to recognize and appreciate the view itself. I've always enjoyed the view.

Thanks for taking the time to enjoy my view of the world.

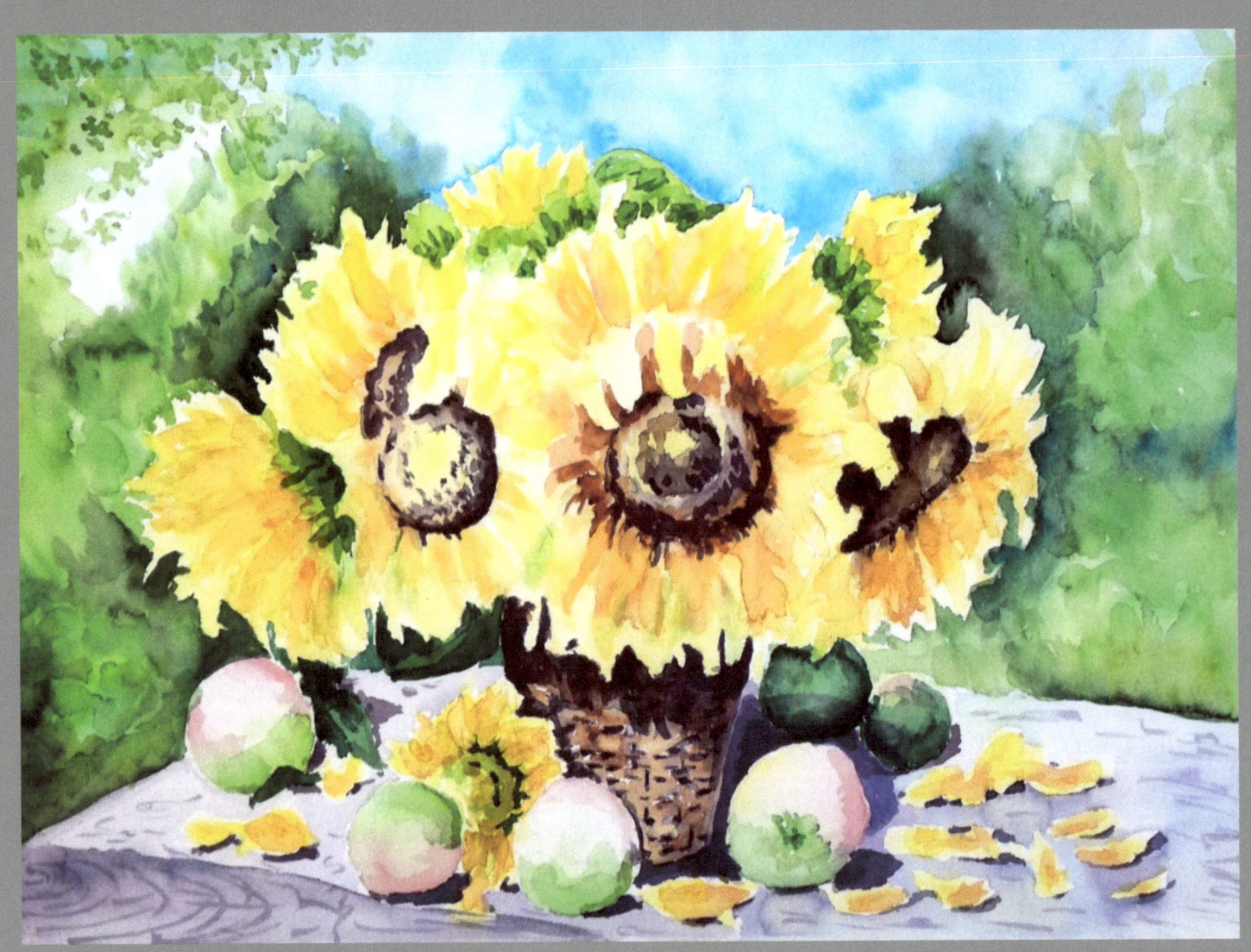

JUDERIA SEVILLA – ART BY LIDIA ESSEN
10.5 X 16.5 INCHES
MEDIA - WATERCOLOR
$ 50.00
lessen@list.ru

Author

I'm 53 year old. I am a lawyer by profession, and I also have a degree in economics and chemistry.
I was born in Siberia and a significant part of my life took place here.
Painting is my hobby since childhood. I grew up in the house of my grandparents. My grandfather was a famous Russian geologist. He was a very talented and well-painted. And though I never studied painting properly, I got my skills thanks to my grandpa, Aleksey.
He also brought up in me a love of nature, so many of my watercolors are devoted to the place where were my summer vacation. We had a small summer house in Siberian taiga, in the village of gold miners, that named Unexpected.
Stunning beauty of nature of Siberia once again inspired me to take paint two years ago.
I paint mainly in watercolor and my style can be called spontaneous. Despite the fact that I just hobbyists, my arts often take private collectors who like the mood of my painting.

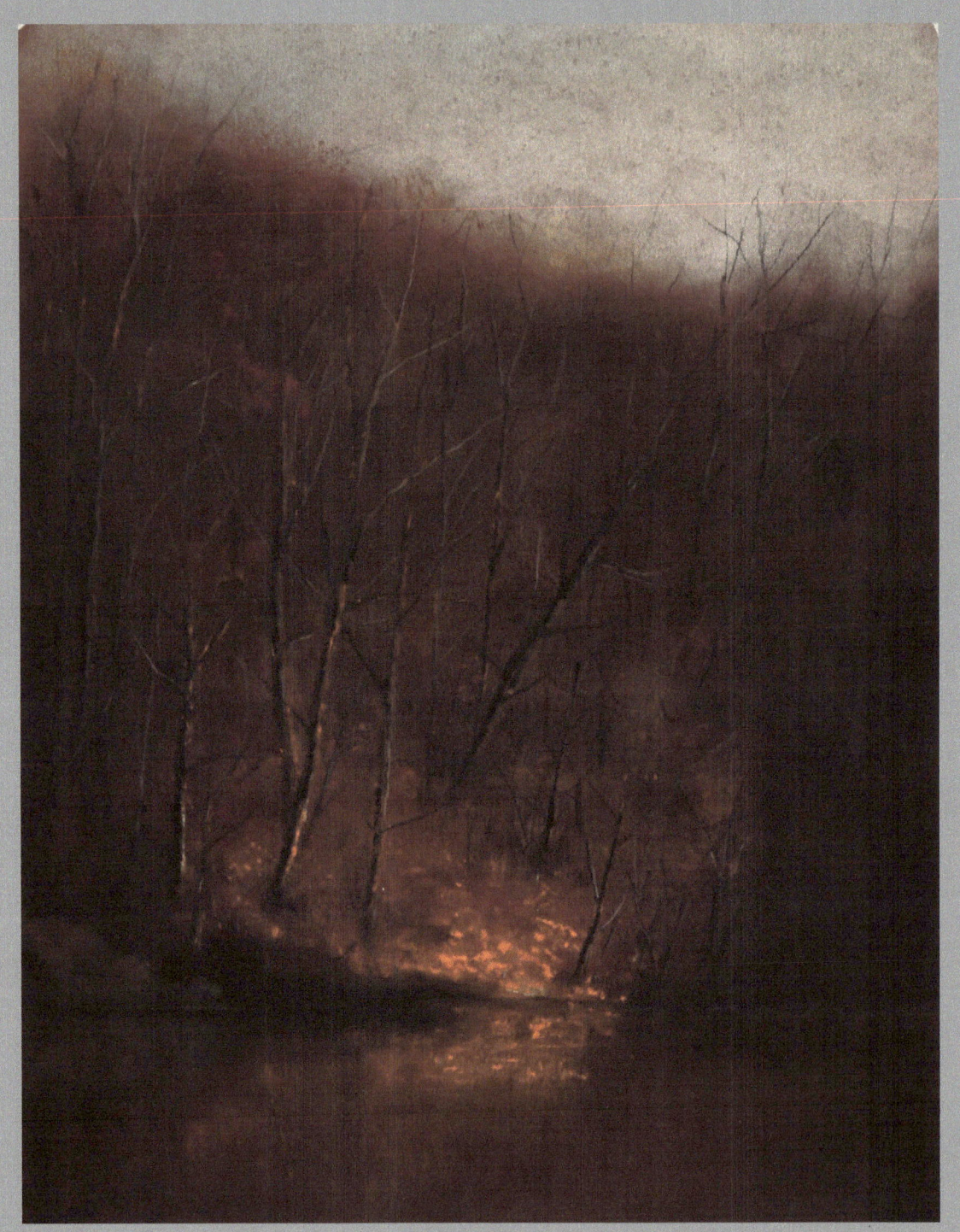

WALK IN THE LIGHT OF YOUR PRESENCE – ART BY GARY SLUZEWSKI
15 X 12 INCHES
MEDIA - PASTEL
$ 650.00

gary@garysluzewski.com

Author

I am passionate about creating works of art reflective of nature. While my work is essentially realistic it is not necessarily literal. It is more about the time of day, the play of light, the subtleties of color and value, and their impact on the landscape. I am interested in expressing an emotional response to the subject and allowing the art to develop rather than representing actual people or places.

I prefer pastel as my medium because I like to feel the painting take shape under my fingers. Much of my drawing is done by applying color directly to the surface from my hands or by roughing out an idea with color and then developing it with my fingers.

I am moved by the beauty placed before us. It is inspiring every time I see a magnificent sky or the depth of reflections on the water. I believe that my ability to create works of art is a gift and I am the instrument to bring it to life.

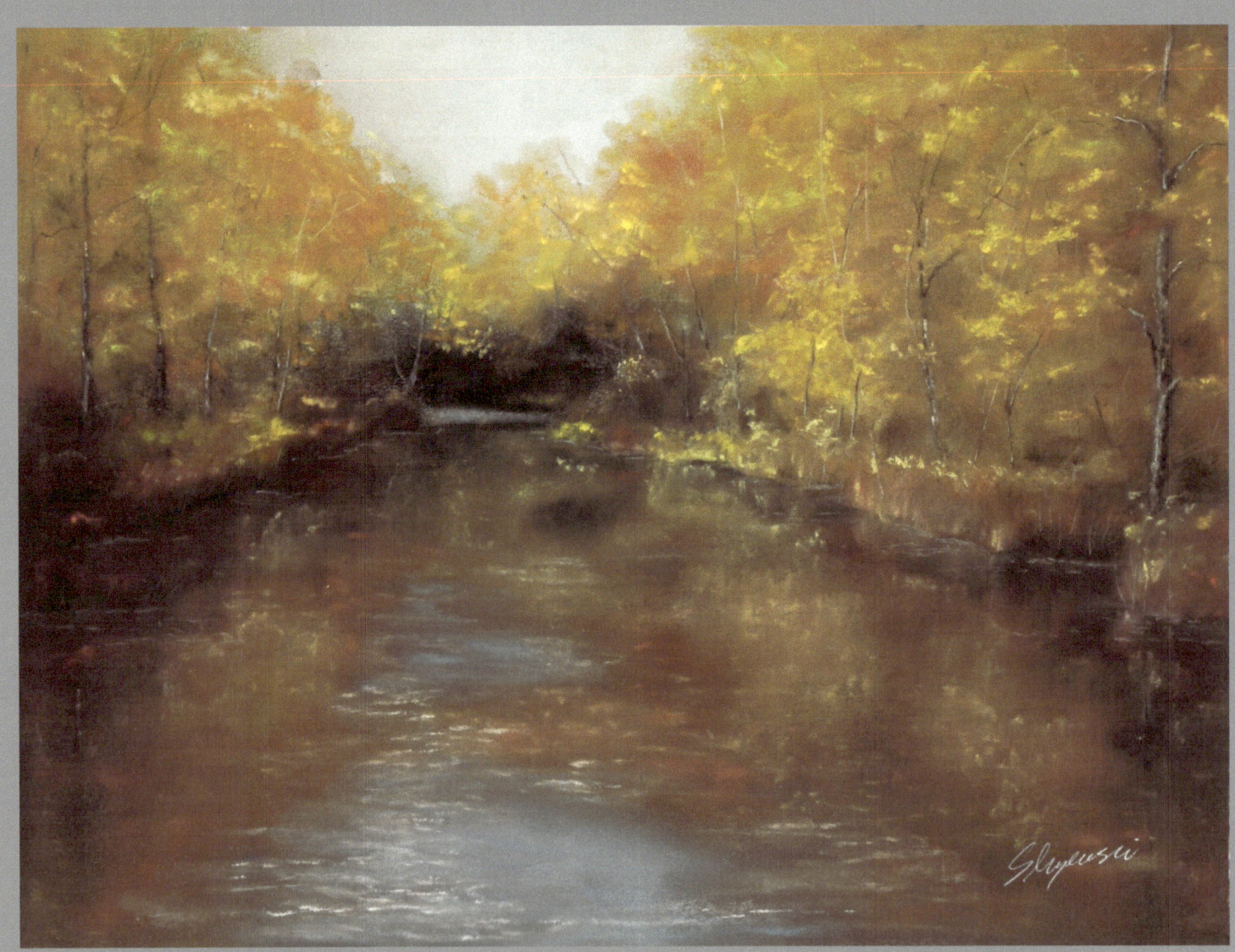

REFLECTIONS – ART BY GARY SLUZEWSKI
12 X 16 INCHES
MEDIA - PASTEL
$ 850.00
gary@garysluzewski.com

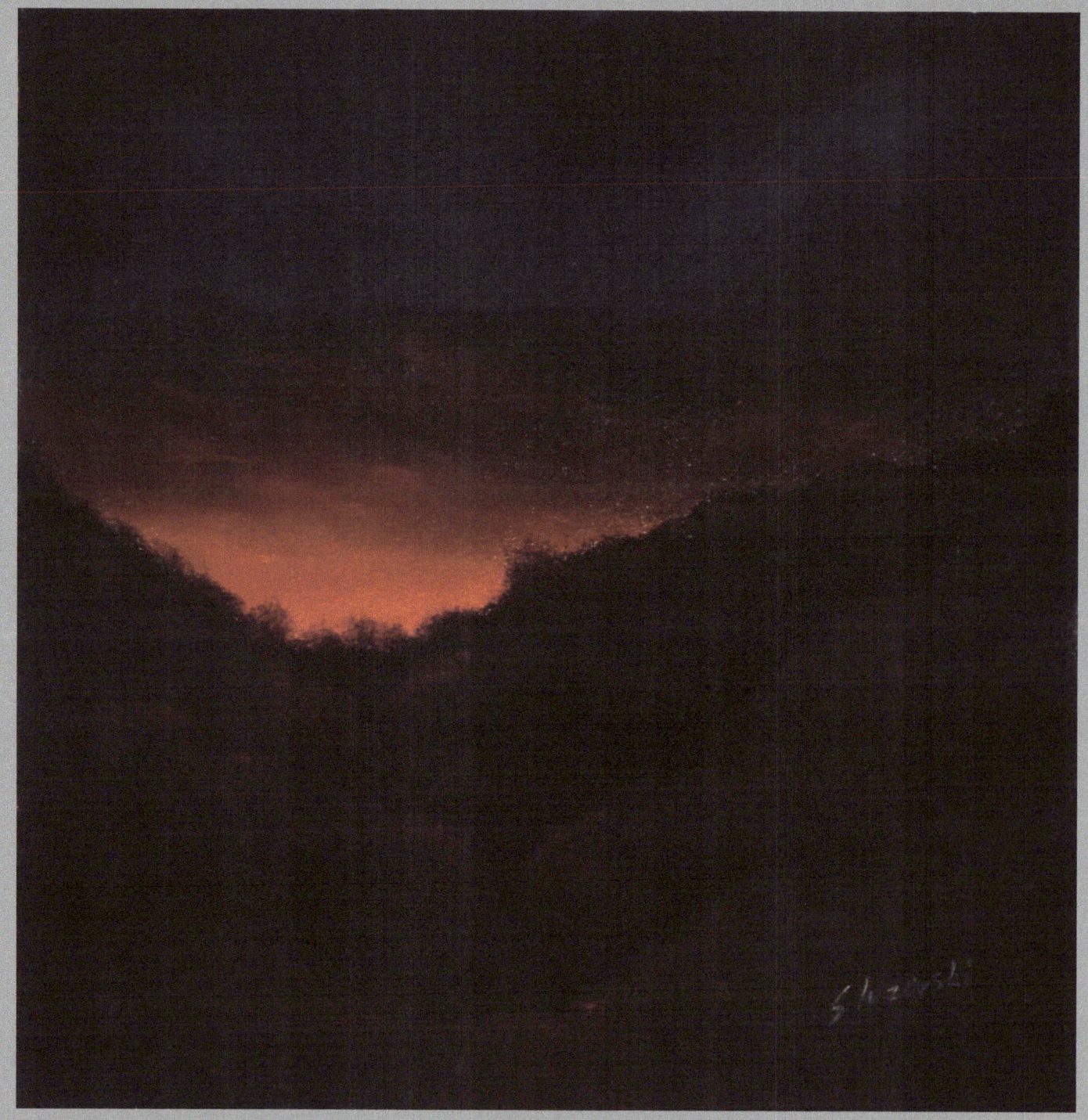

SUNDOWN – ART BY GARY SLUZEWSKI
9.5 X 9.5 INCHES
PASTEL
$ 450.00

gary@garysluzewski.com

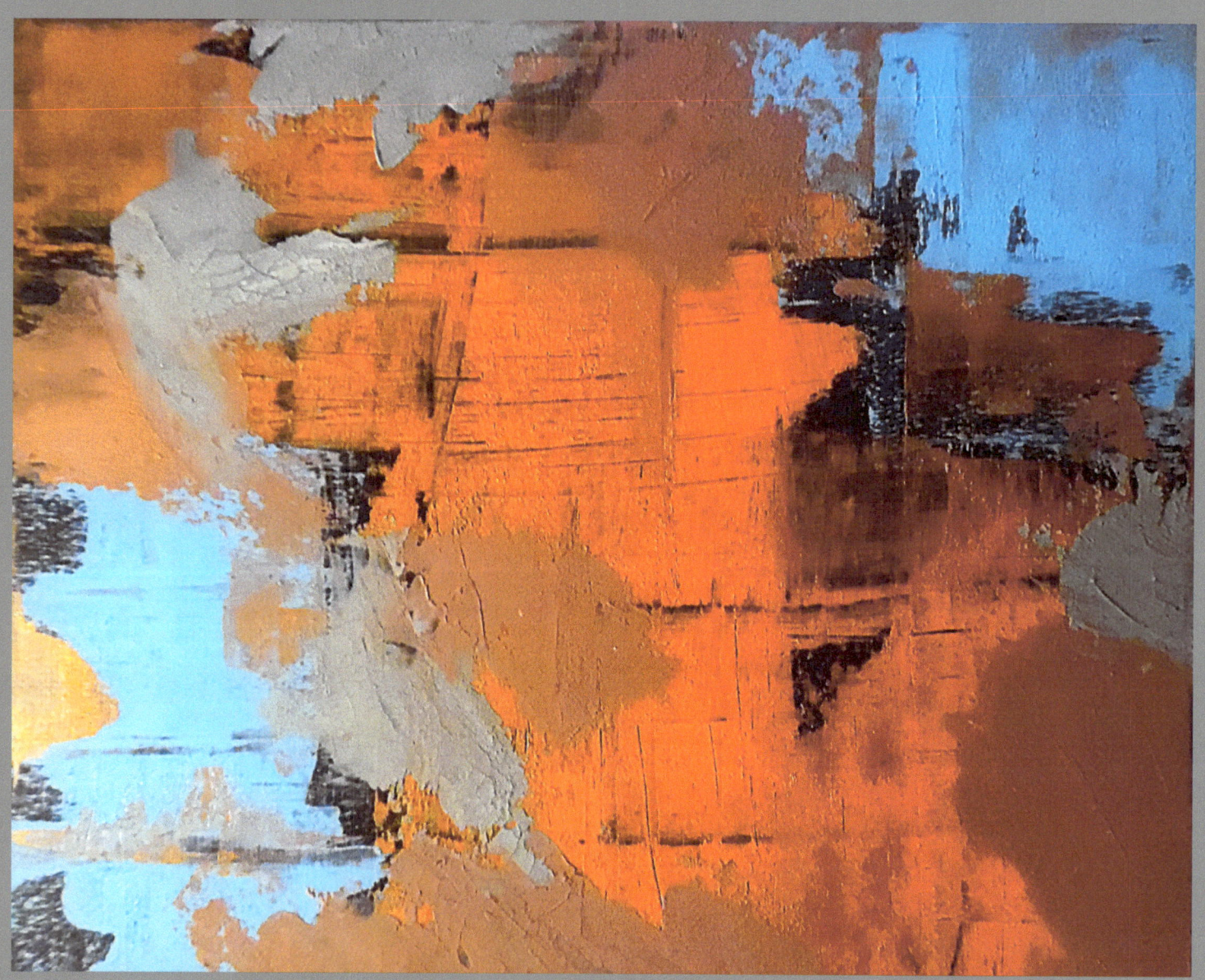

BEAUTY OF DECAY – ART BY JILIAN CRAMB
920 X 16 INCHES
MEDIA - ACRYLIC ON CANVAS
$ 325.00
asherjacobsmommy@gmail.com

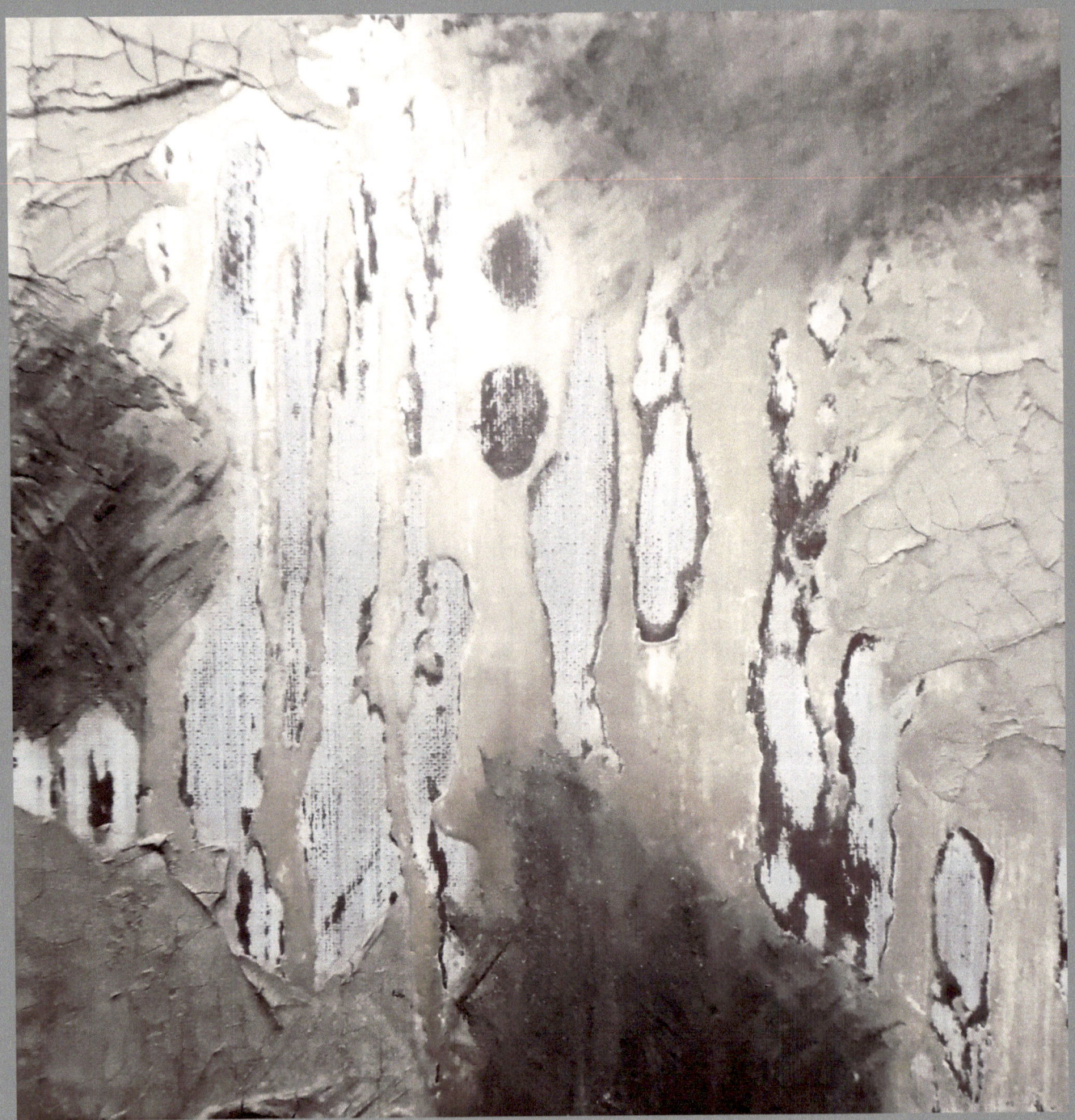

BRASS BARK – ART BY JILIAN CRAMB
12 X 12 INCHES
MEDIA - ACRYLIC ON CANVAS
$ 190.00
asherjacobsmommy@gmail.com

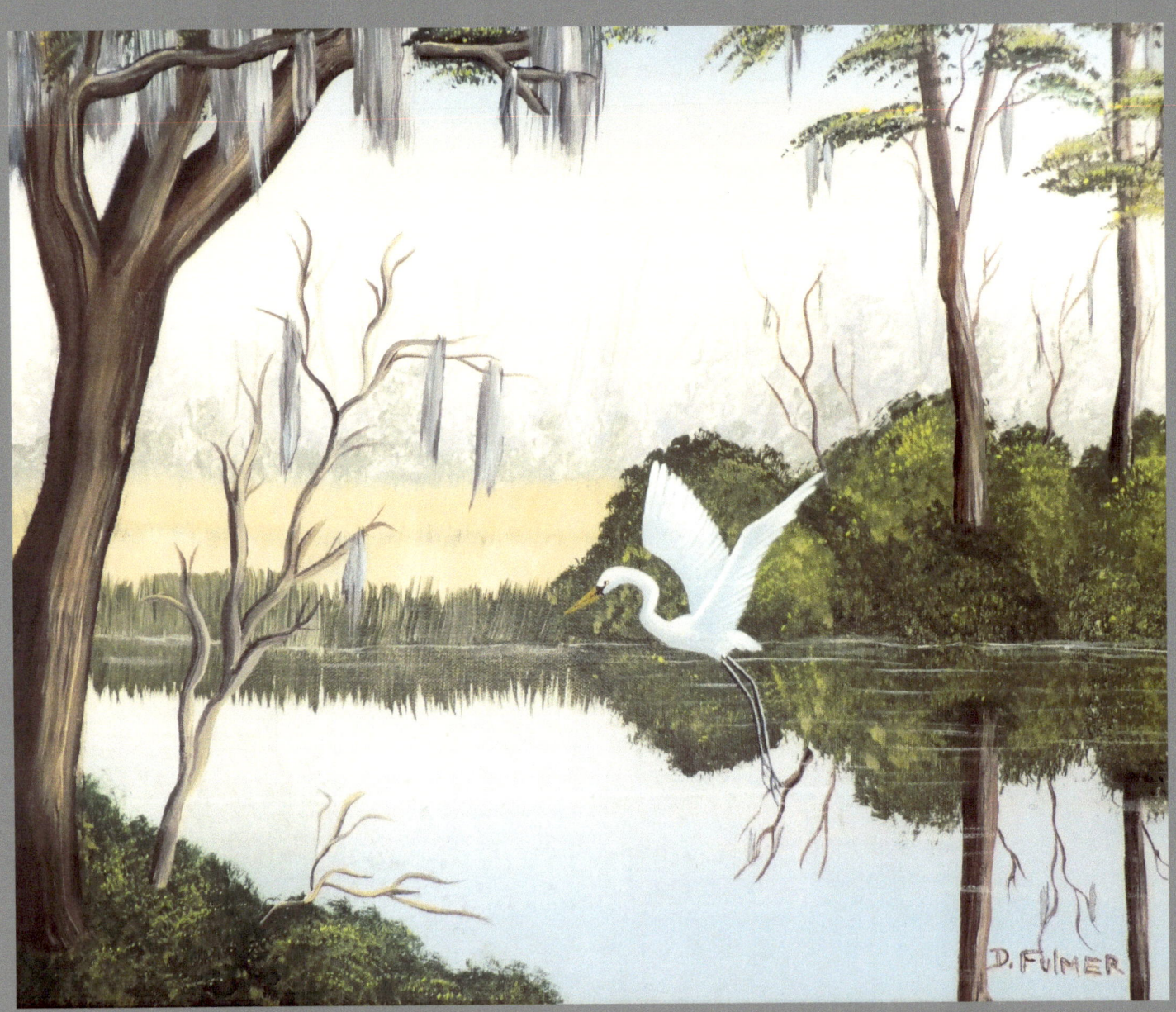

EGRET IN FLIGHT 1 – ART BY DENISE FULMER
19.5 X 15.5 INCHES
MEDIA - ACRYLIC ON CANVAS
$ 250.00
dffladybug@gmail.com

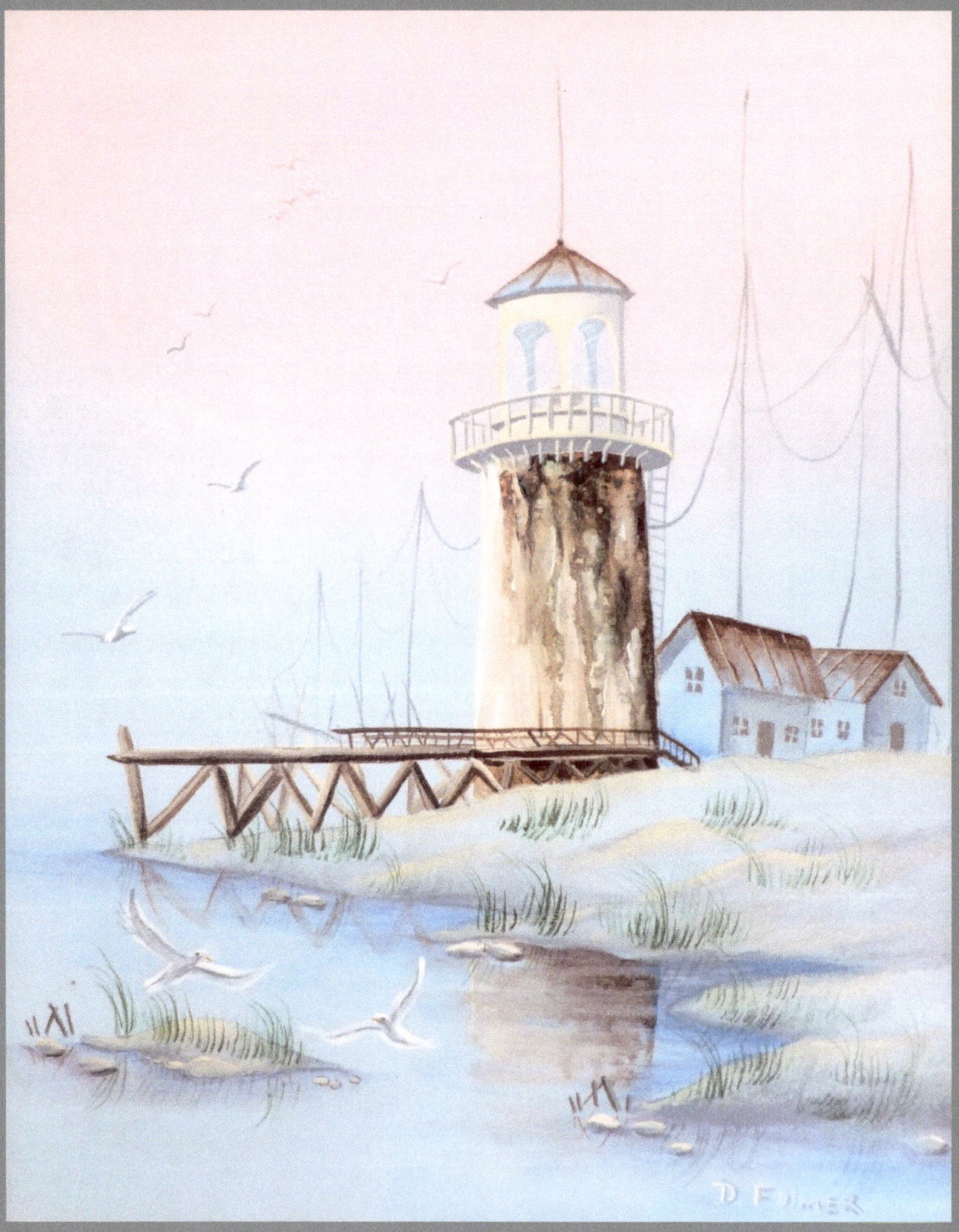

LIGHTHOUSE – ART BY
DENISE FULMER
15.5 X 19.5 INCHES
MEDIA - ACRYLIC ON CANVAS
$ 250.00
dffladybug@gmail.com

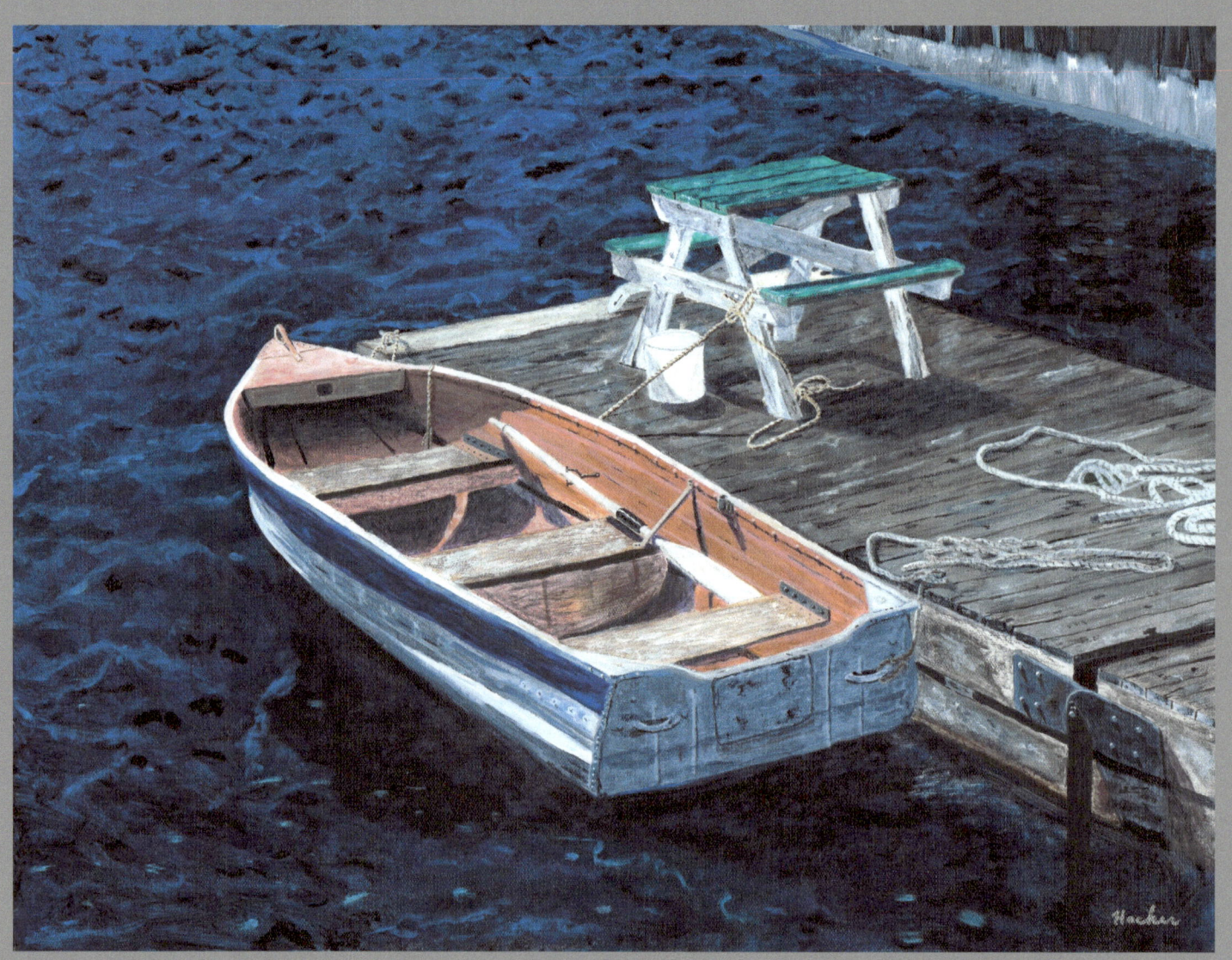

BLUE ROWBOAT – ART BY TIMOTHY HACKER
24 X 18 INCHES
MEDIA - ACRYLIC ON CANVAS
$ 500.00

thacker@bex.net

Author

I am a semi-retired physician with a longstanding keen interest in photography. I have been photographing for many years. I continue to be and have been juried into many art shows and I have won many awards in various contests I have entered. I have had several works at the Collectors Corner gift shop at the Toledo Art Museum. I have pieces in several art galleries.

I also do acrylic paintings which occupy more of my time now than photography.

You can find more artworks on www.timhacker-docshots.com Also http://timothy-hacker.artistwebsites.com

BRUTUS GARAGE – ART BY TIMOTHY HACKER
18 X 12 INCHES
MEDIA - ACRYLIC ON CANVAS
$ 225.00
thacker@bex.net

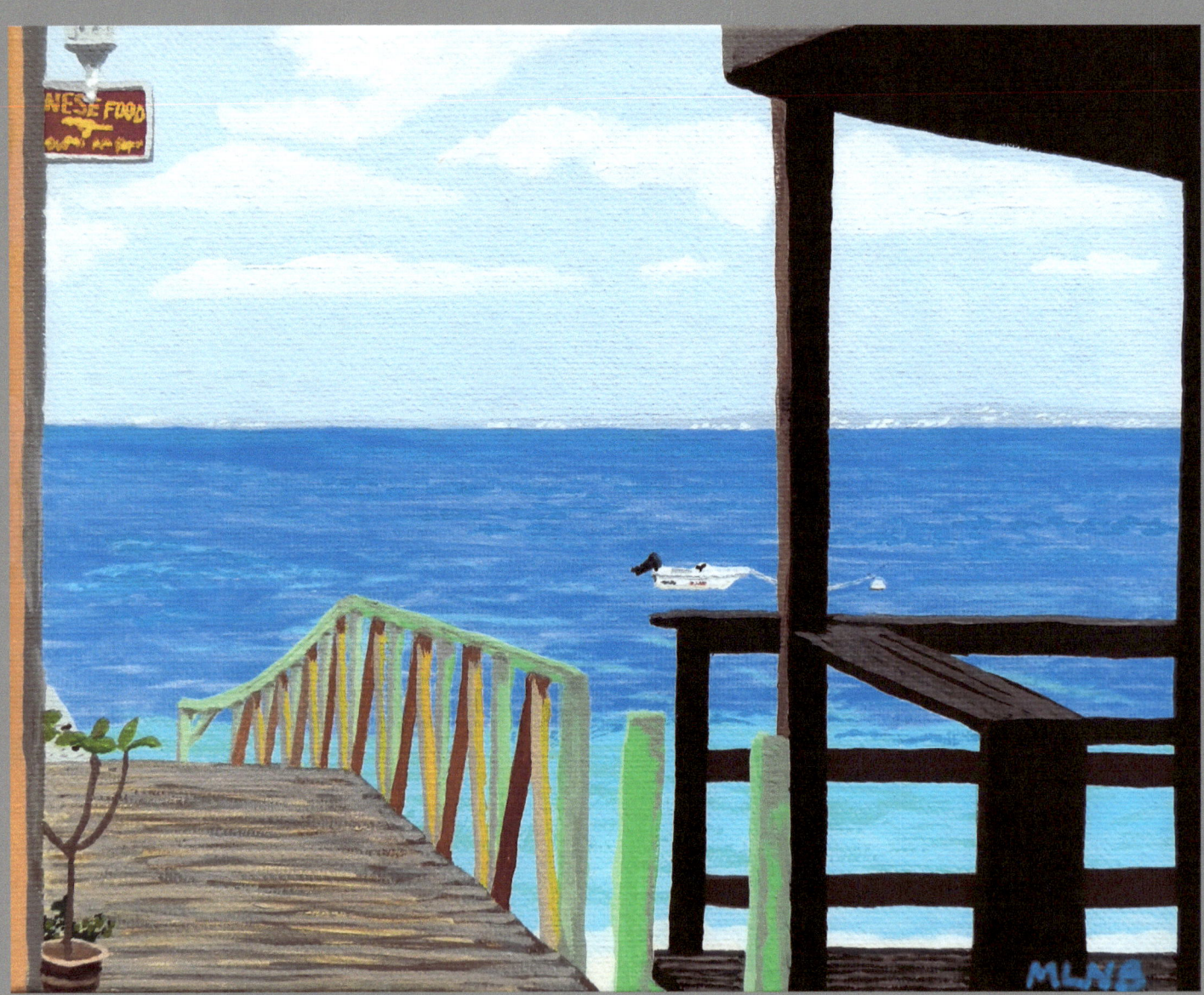

LOOKOUT ALONG GREAT CASE BEACH – ART BY MARGARET BROOKS
10 X 8 INCHES
MEDIA - ACRYLIC ON CANVAS
$ 450.00

maggielnb@gmail.com

Author

Margaret L.N. Brooks (aka Maggie) is the granddaughter of the late, prolific watercolor and oil painter Laura J.A. Neese of Beloit, Wisconsin, and was highly inspired by her to develop her own talent, which first appeared in .grammar school in the UK.

Living in St. Maarten in the northeastern Caribbean since her 20s, she paints mostly Caribbean scenes, and her travels through Europe have occasioned some pieces from there as well.

She focuses on landscapes and seascapes, but also dabbles in abstract art and portraits. Five of her works won Special Recognition and one Special Merit in Light Space and Time Online Art Gallery's Art Competitions held June through November 2015. Her websites are margaret-brooks.artistwebsites.com and www.artbymargaret.com .

A graduate in physics, Margaret's hobbies include classical piano, languages, travel and online education.

A mother of 4, Margaret and her husband Tonca, a reggae artist from St. Maarten, built the first audio recording studio in St. Maarten in 1984. It still exists today in South Reward. After managing the studio for many years, Margaret is now an editor of local newspaper The Daily Herald

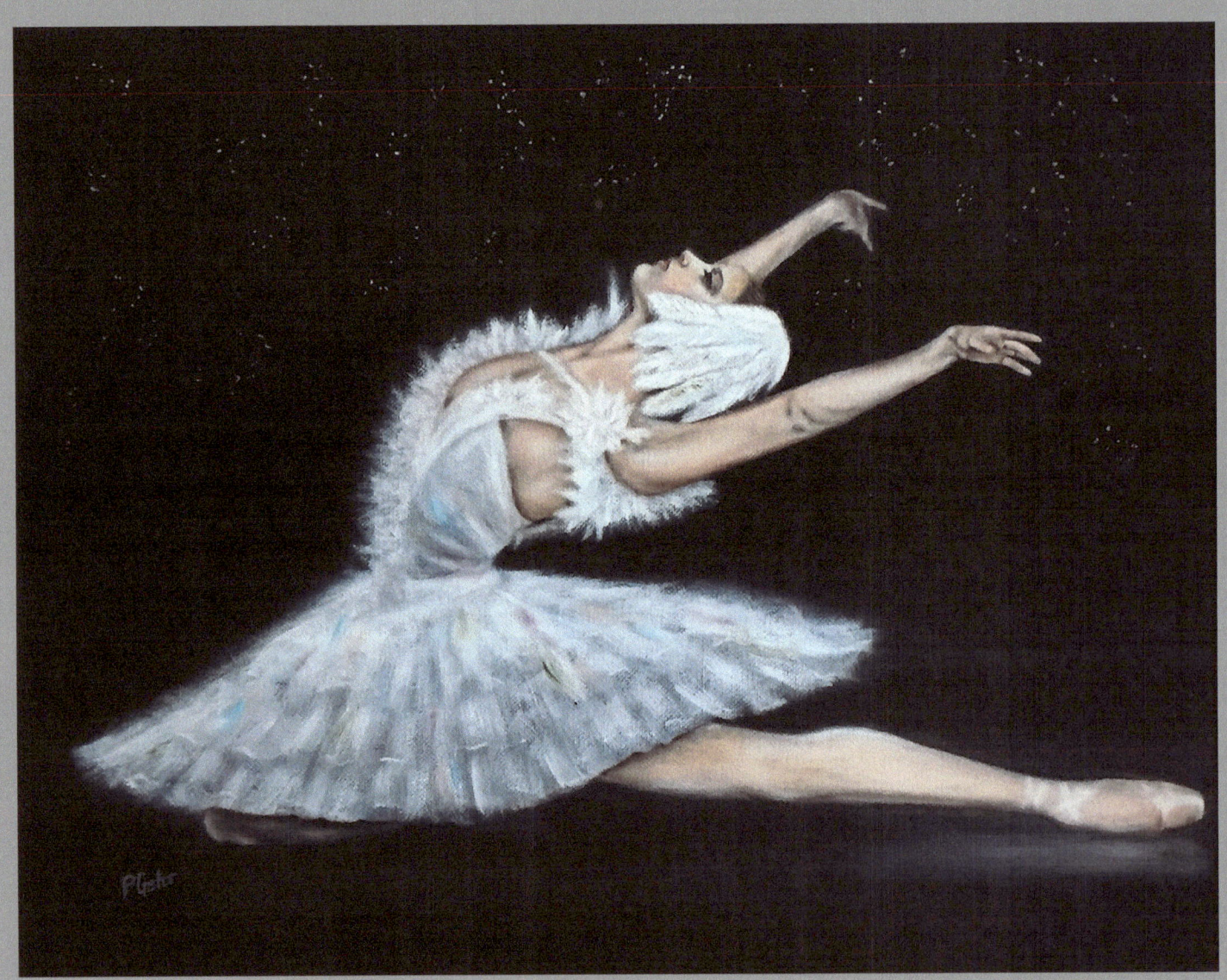

PRIMA BALLERINA – ART BY PAT GEHR
18 X 14 INCHES
MEDIA - OIL ON CANVAS
$ 1500.00
PGehrPhD@aol.com

Author

My professional background is that of serving others as a clinical psychologist. Since childhood, however, I have always had a strong passion for art…that of painting. As such, one day I decided to attempt a portrait of our rescue tuxedo cat, Max. Our beloved Eskie became my next project which further reinforced my desire to develop my skills in painting. Reflecting on these experiences I have come to realize that they served to launch an incredible journey for me in the world of art. I now accept commission work as well as continue painting for the intrinsic rewards it offers me.

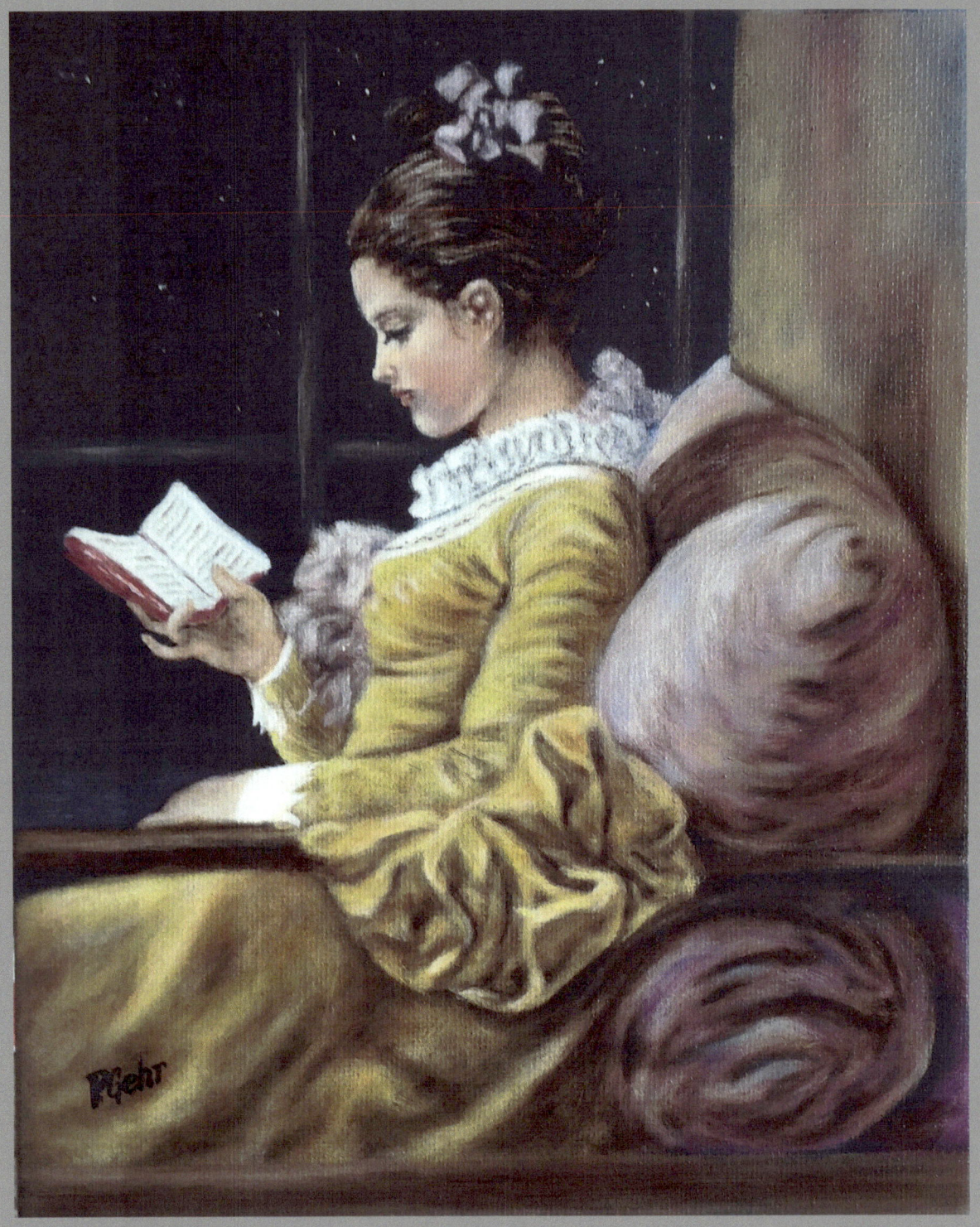

NOCTURNE INSPIRED BY FRAGONARD – ART BY PAT GEHR
8 X 10 INCHES
MEDIA - OIL ON CANVAS
$ 600.00
PGehrPhD@aol.com

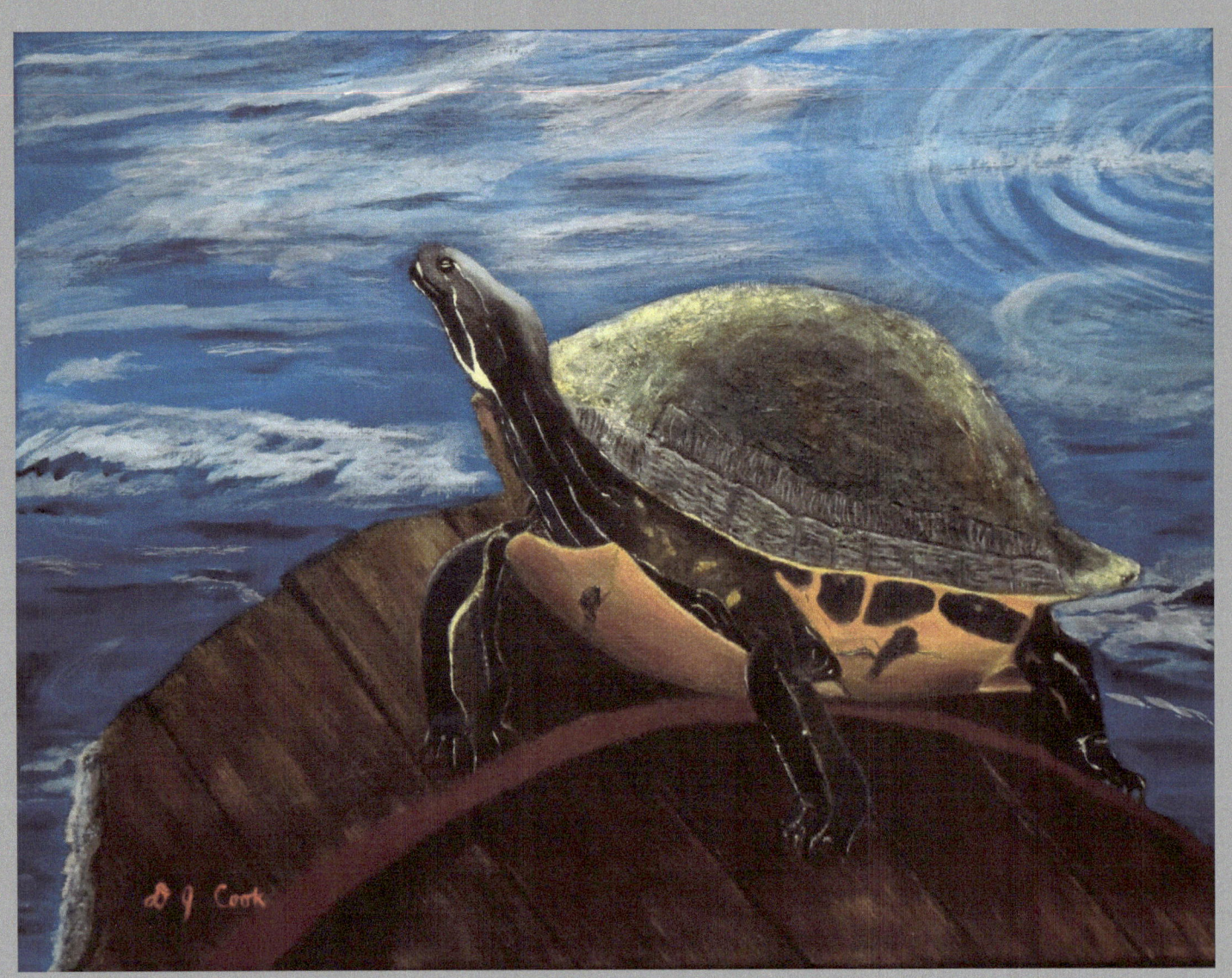

SUN BATHING – ART BY DONNA COOK
16 X 12 INCHES
MEDIA - ACRYLIC ON CANVAS
$ 150.00

djcook60@gmail.com

<u>Author</u>

I am an Acrylics Artist with an insatiable appetite for art and exploring my creativity. I am incredibly blessed with a beautiful family life shared with my husband and son. As a full time artist, I am fortunate to travel with my family which greatly inspires new creations. I have enjoyed painting for quite some time. I have much time and passion for devotion to my craft.

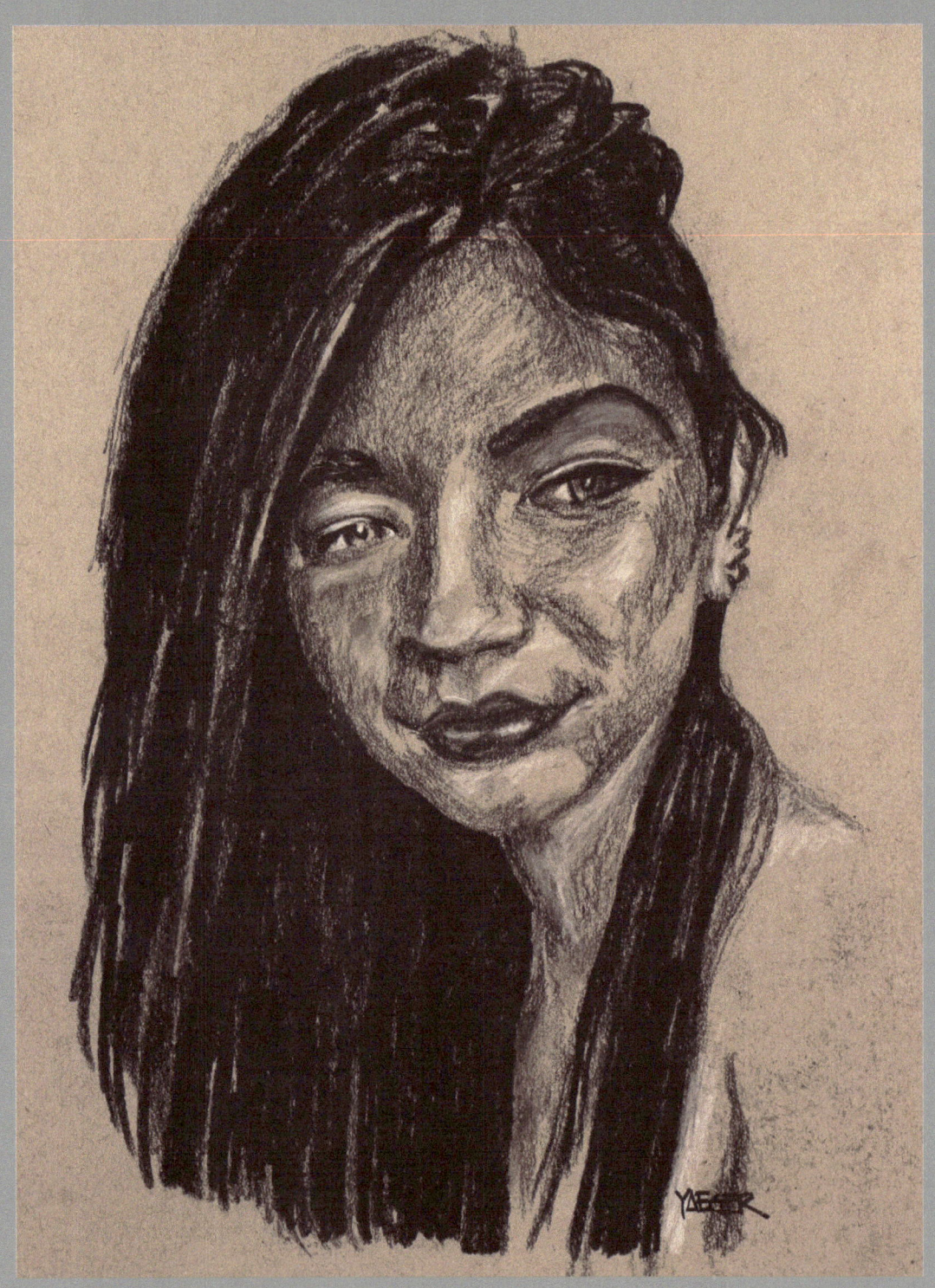

RARE BEAUTY – ART BY ROBERT YAEGER
9 X 12 INCHES
MEDIA - CHARCOAL AND PENCIL ON PAPER
$ 300.00

robyaegerart@gmail.com

Author

I am an artist and photographer. I create portraits of people, homes, and a wide variety of paintings, drawings, and artistic photography.

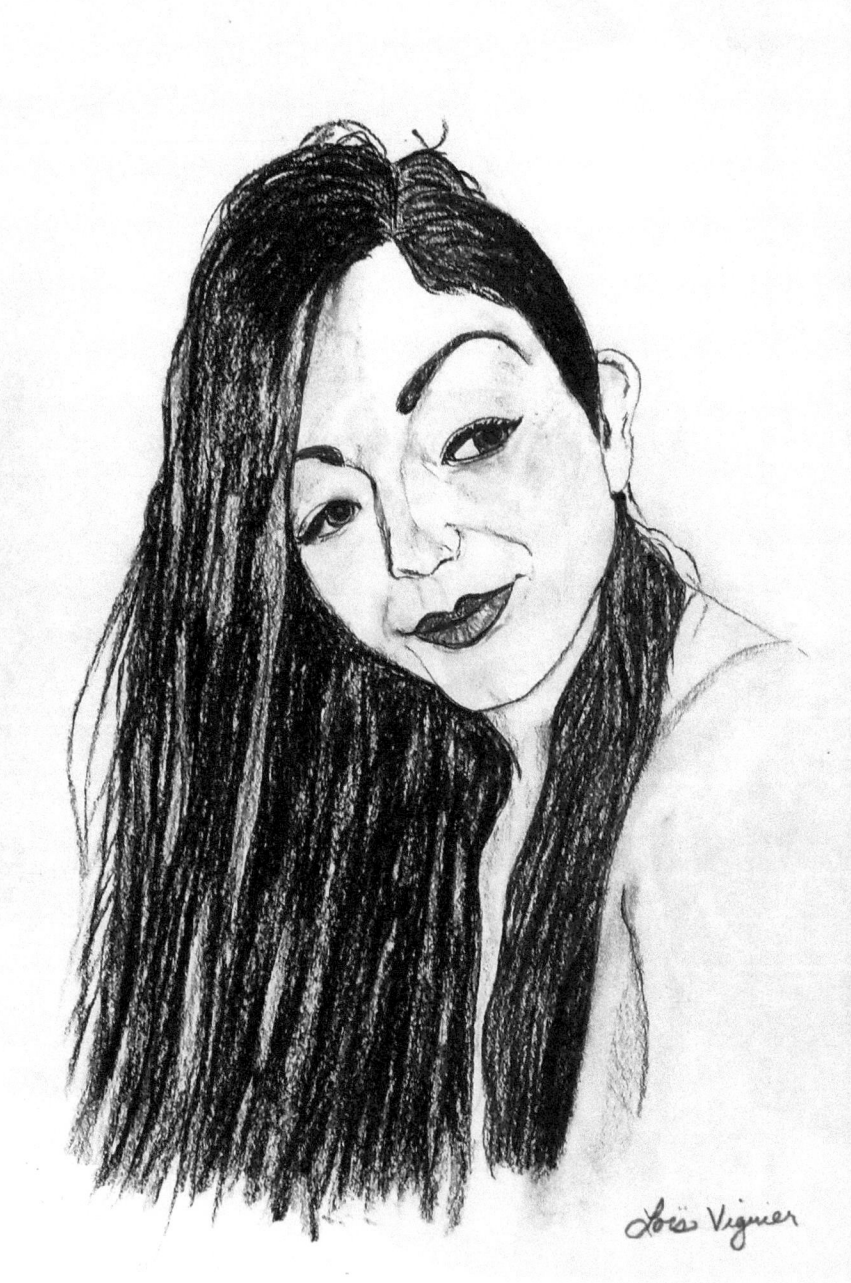

THE BEAUTY – ART BY LOIS VIGUIER
8.5 X 12 INCHES
MEDIA - PENCIL AND CHARCOAL
$ 30.00

gloryenterprises.lois@gmail.com

<u>Author</u>

I am an American, married to a French pastor, living in France. I have 6 children and 6 grandchildren.

I started painting in watercolors, then on porcelain.
Now I'm also painting with acrylic, and having a great time!

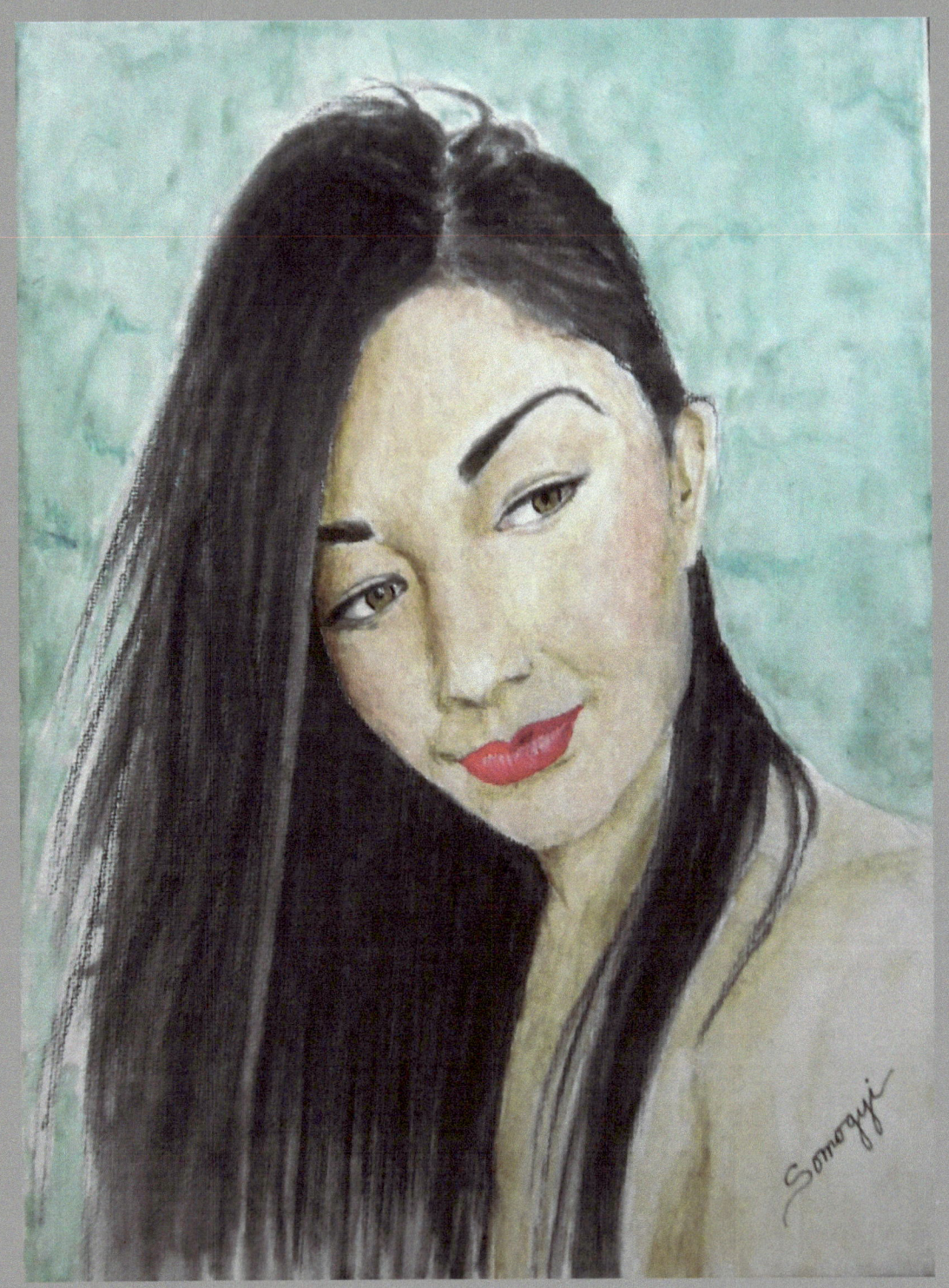

CONTESTANT NUMBER 4 – ART BY JAYNE SOMOGY
9 X 12 INCHES
MEDIA - ACRYLIC, INK AND CHARCOAL ON CANVAS
$ 130.00

najahbellydancer@aol.com

Author

Jayne Somogy—who signs her work as "Somogyi," the ethnically-correct spelling of her Hungarian surname—was born and raised in Ohio, attended college in Indiana & Wisconsin as an art/theatre major, lived most of her life in Los Angeles, and "retired" in 2008 to Conyers, Georgia after a long career as an administrative assistant, legal secretary, proofreader, & graphic artist. But her heart was always in the arts, and that's how much of her free time was spent—acting, singing, dancing, drawing, designing, often on a semi-professional level and earned an additional degree in fashion design from FIDM.

Jayne has had a lifetime love affair with the exotic—people, places, objects, music—and her favorite artistic subjects are people, and most especially, people she is never likely to meet—interesting but for the most part anonymous figures from the past who serve to define their particular time and place; individuals from the dwindling tribes of indigenous people in places she has never been; and those unique folks that many consider to have been "freaks of nature" because they didn't look like the rest of us. And because she has been an entertainer all her life, she particularly loves portraying dancers from every discipline and every part of the globe, but most especially belly dancers, her own chosen form of dance. All these individuals are rendered with love, a lightness of touch, a sense of humor, and from a sensitive soul-space that evokes a positive response from the viewer.

Jayne works in pastels, charcoal, art markers, ink, & colored pencil, has a fine attention to detail and an adventurous approach to color.
~ Jayne also designs and makes one-of-a-kind belly dance costumes, available from her etsy.com shop, RaqsRags or on Facebook/Raqs Rags.

ABOUT THE AUTHOR

At the age of 15, he started to write short stories, poems, screen plays. When 19 of age, worked as technician at the film studios, department for special effects and light. Worked also on movie Amadeus, directed by Oscar winning director, Milos Forman. At age 24, emigrated to United States. In 1989 moved to California where he joined theatre group Gilbert & Sullivan. During his stay in California went to Santa Barbara Community College where he visited several accredited courses as Business law and Design. After death of his father in 2001, he returned to his birth country where he worked as Quality Engineer, Quality Assurance manager and Manufacturing Project Manager. In quality assurance he got Black Belt / 6 Sigma training while working in automotive industry.

He had few art shows in Europe and United States. On top of fine art painting, he also started to do sculptures and the other strong activity that he spent a lot of time with – design inventions, technical and design improvements in fields like optics, acoustics and motion picture E^2E^2 systems. Currently he writes his second book which is also written in parallel, as screen play for the film.

E MAIL CONTACT: motyl_1999@yahoo.com

www.ingramcontent.com/pod-product-compliance
Lightning Source LLC
Chambersburg PA
CBHW051026180526
45172CB00002B/482